IMAGES
of America
WILLIAMSBURG

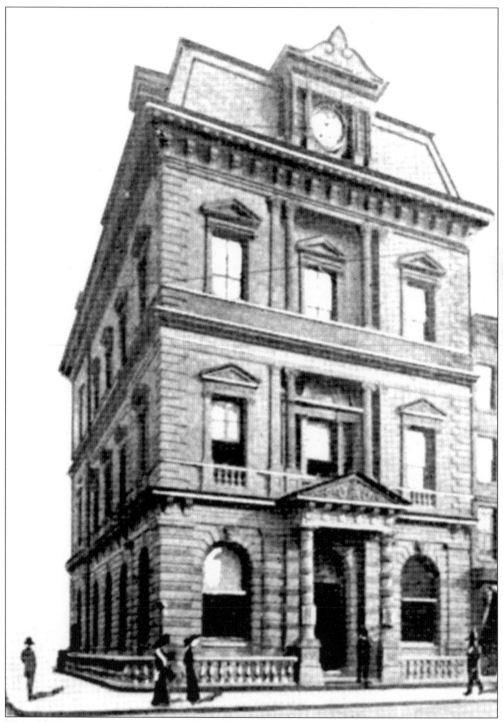

The old Kings County Savings Bank building, at 135 Broadway on the northeast corner of Bedford Avenue, is one of Williamsburg's greatest and most photographed landmarks. The 1868 building is exceptionally well preserved, looking today as it does in this retouched *Brooklyn Daily Eagle* photo postcard, taken *c.* 1910.

IMAGES
of America

WILLIAMSBURG

Victor Lederer and the
Brooklyn Historical Society

ARCADIA

First published 2005

Published by Arcadia Publishing,
Charleston SC, Chicago IL, Portsmouth NH, San Francisco CA

Printed in Great Britain

Library of Congress Catalog Card Number: 2004118342

For all general information, contact Arcadia Publishing:
Telephone 843-853-2070
Fax 843-853-0044
E-mail sales@arcadiapublishing.com
For customer service and orders:
Toll-free 1-888-313-2665

Visit us on the Internet at www.arcadiapublishing.com

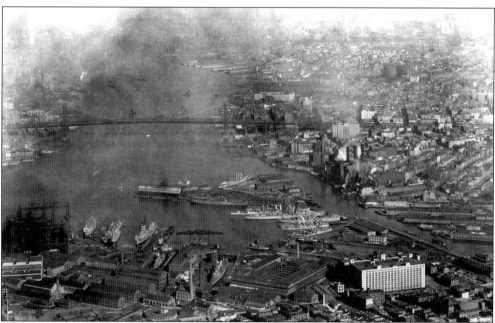

Looking north along the East River, this majestic c. 1940 aerial view shows Manhattan at the upper left, Williamsburg at right, and the massive span of the Williamsburg Bridge connecting them. Much of the photograph's lower half is taken up by Wallabout Bay, home of the Brooklyn Navy Yard, where more than a dozen large vessels can be spotted.

CONTENTS

ACKNOWLEDGMENTS

Having spent the better part of a year looking at Williamsburg and photographs of Williamsburg, it seems to me that no pictorial history can provide more than an overview of this extraordinary part of the world, but surely the Brooklyn Historical Society's great collection is one of the richest veins to mine for images. Thanks to Marilyn Pettit, Jeff Barton, Kate Caiazza, Jill Annitto, Sean Ashby, Jasmine Sepulveda, Kate Fermoile, and Jessie Kelly at the society for the opportunity to assemble this book, and for their cooperation, trust, and friendship.

My thanks also go to Pfizer for the use of six images from its fine archive, and specifically to Anna Gasner for her help in obtaining them. I am grateful to Dave Pirmann of nycsubway.org for explaining Brooklyn's old commuter train system. I owe thanks to Erin Loftus, Tiffany Howe, Brendan Cornwell, Will Willoughby, and Kaia Motter at Arcadia Publishing, wonderfully calm professionals who eased me through the rough spots. My aunt Gert Oltchick generously shared her first-hand knowledge of Williamsburg's streets and businesses, and was a constant and enthusiastic supporter of this book from the start. Thanks, as always, to my son Paul for his interest and encouragement, and to my wife, Elaine, for her unfailing support and love. I am especially grateful to my daughter Karen for taking the excellent photographs of contemporary Williamsburg in chapter 7, a cold day's hard work in January 2005.

INTRODUCTION

Williamsburg, Brooklyn, lies directly across the East River from Manhattan's Lower East Side, to which it has been linked since 1903 by the Williamsburg Bridge, and with which it shares a history of immigration and poverty and of decline followed by an astonishing rebirth.

Dutch farmers replaced a Native American community on Brooklyn's East River shore with a cluster of houses at what is now the foot of Metropolitan Avenue. In 1660, the riverside hamlet became part of the town of Boswijck, today called Bushwick, Williamsburg's neighbor to the east. Following the Revolutionary War, which was hard on all of British-occupied New York, what was to become Williamsburg was a little farm town known as Cripplebush. This soon became a suburb for wealthy New Yorkers who wanted to get away from a crowded and filthy Manhattan, where yellow fever flourished alongside commerce. Richard Woodhull, operator of a ferry between Corlear's Hook in Manhattan and South Second Street, hired Jonathan Williams to survey the district. Originally called Williamsburgh, the town was named for this minor historical figure.

Williamsburg's history in the 19th and 20th centuries was shaped by its riverside setting and by the businesses that sprang up after the 1825 opening of the Erie Canal, making New York the conduit for trade into the North American interior and transforming Williamsburg from an affluent suburb to the city's most industrialized, densely populated, and impoverished neighborhood. The canal, combined with New York's great natural harbor, brought the city a huge economic boon by enabling cheap transportation of goods in bulk up the Hudson, across New York State, and to the Great Lakes. With the opening of vast markets, industrialists built their factories along the city's waterfront, where supplies could be brought in and finished products shipped at the lowest cost. Williamsburg's businesses prospered and its population grew through the 19th and early 20th centuries, but large portions of the community suffered from their proximity to heavy industry, falling fast and hard when factories closed as New York de-industrialized after World War II.

Williamsburg's transformation from quiet suburb to factory district was rapid. When the little community incorporated in 1827, its population was about 1,000. By 1840, it had 5,000 residents, and by the time it was reorganized as an independent city in 1851, the town's population had exploded to 32,000. In 1855, Williamsburgh joined the city of Brooklyn and dropped the final "h" from its name but held its own distinct identity within the borough, which was then mostly suburban. Williamsburg has continued to maintain its own character within the city since the five boroughs merged into greater New York on January 1, 1898.

By the middle of the 19th century, Williamsburg was a thriving industrial town containing many large factories owned by wealthy residents and worked by poor laborers, mostly immigrants from Germany and Ireland. The second half of the 19th century, Williamsburg's boom years, also saw the construction of many of the area's architectural treasures. Chiefly on or near Broadway, these include the old Williamsburgh Savings Bank and Williamsburg Trust Company buildings with their conspicuous domes, many beautiful churches, and several cast-iron masterpieces that rank with the best in SoHo.

Quite a few of today's industrial giants have roots in mid-19th-century Williamsburg. These include Astral Oil, which eventually merged with Standard Oil, now Exxon-Mobil, and Brooklyn Flint Glass, an ancestor of Corning Glass. The Havemeyer and Elder sugar refinery operated under different corporate names, including Domino, Amstar, and Tate and Lyle, at a huge waterfront plant until 2004. Pfizer Pharmaceuticals, founded in Williamsburg in 1849, still runs a packaging facility on Flushing Avenue. Other plants included foundries, ironworks, distilleries, breweries, glue factories, and the Brooklyn Navy Yard, which anchors the neighborhood's southwestern boundary. Some of the biggest and most noxious plants crowded Williamsburg's once tranquil East River shore, driving away all who could afford to move and leaving underpaid laborers. By 1900, the area was populated chiefly by working-class families.

More than 100,000 eastern European Jewish immigrants poured into the Williamsburg melting pot over the decades following the opening of the Williamsburg Bridge in 1903, in flight this time from the packed slums of Manhattan's Lower East Side. The neighborhood's population of 105,000 in 1900 shot to 260,000 by 1920, speeding its deterioration. Living conditions were soon just as bad as they had been across the river, with poverty, crime, filth, and appallingly overcrowded housing and schools again motivating families to escape at the earliest opportunity. Williamsburg's population fell sharply after World War II as the area's base of industrial jobs began to dry up.

The decades following World War II were grim for Williamsburg; many of its houses were abandoned, and the cutting of the Brooklyn-Queens Expressway through the heart of the area devastated scores of blocks. As New York's economy bottomed out in the mid-1970s, the oldest and most industrialized sections near the river seemed blighted beyond reclamation. But the decline of the neighborhood, which is in fact a patchwork of a half-dozen interwoven sub-districts, was neither absolute nor universal. Northwestern Williamsburg, bordering Greenpoint, has long been home to a large, stable Polish population. Predominantly Italian northeastern Williamsburg, with its attractive, treelined streets of single-family homes, staunchly resisted the rot that afflicted other parts of the neighborhood. Ultraorthodox Hasidic Jews from Hungary and Romania settled before and after the war around Bedford Avenue, south of Broadway, and Puerto Ricans established a colony centered along Graham Avenue in East Williamsburg, forming the vanguard of what is today a large, diverse, and vibrant Hispanic community.

Williamsburg's history is still in the making. New York's primacy over the national culture and imagination solidified as the city's new, service-based economy strengthened and crime fell through the 1980s and 1990s. Once the city was perceived as exciting, desirable, and safe, real-estate values and rents rose steeply. Artists, followed by the urban pioneers who had turned the East Village and Lower East Side into hip, attractive districts, moved into the desolate heart of old Williamsburg in search of cheaper rent with a Manhattan view and subway service, soon trailed by galleries, bookstores, cafés, and shops. In a sovereign display of New York's power of self-renewal, Williamsburg has metamorphosed from the city's poorest and least fashionable neighborhood into one at the cutting edge.

One

OLD WILLIAMSBURG

The oldest photographs of Williamsburg in the Brooklyn Historical Society's collection, which date from the 1870s, include exquisite images on glass negatives showing modest frame structures on dusty streets. Others, taken by the antiquarian Eugene Armbruster in the 1920s, capture the remnants of the old town. Only a few of the older and smaller structures Armbruster photographed remain today, making his photographs an invaluable record of a vanished time and place.

These images cover different areas of the sprawling district. Those taken along the Broadway corridor show the commercial heart of a booming New York suburb in its era of greatest growth and prosperity. We see banks and insurance companies, tobacconists and tailors, restaurants, and the omnipresent bars and beer halls of early-20th-century New York. Others, shot on quieter side streets near the East River, offer glimpses of Federal and Greek Revival houses, some still attractive, others forlorn, in a densely populated neighborhood that has outgrown them. The images from the eastern edges of Williamsburg, bordering on Greenpoint, Bushwick, and Ridgewood, are altogether different, capturing the area's sharp transformation from rural to urban. Farm structures owned by old Brooklyn families sit at odd angles to streets lined with the row houses that are homes to some of the borough's newest residents.

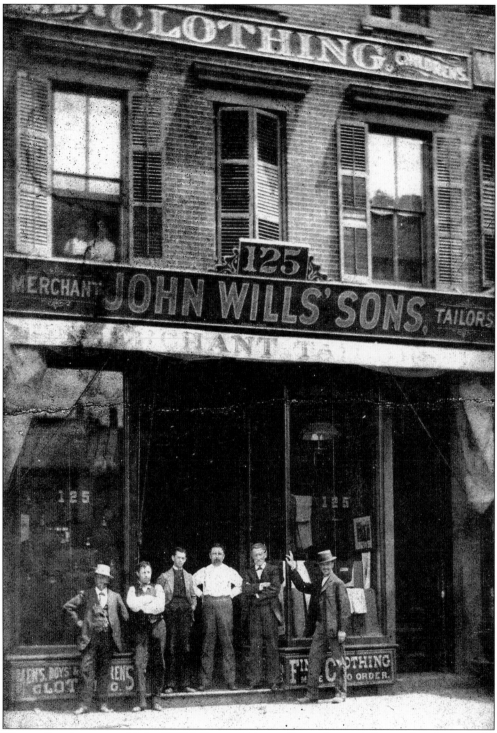

The staff and owners of John Wills' Sons stand proudly in front of their tailor shop at 125 Broadway c. 1880. The inscription on the back identifies the man in the white shirt at center as Anthony Wills and the older man at far left as John Wills himself.

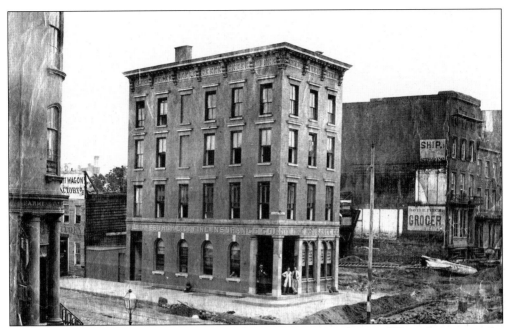

The headquarters of Williamsburgh City Fire Insurance, on Broadway and Kent Avenues, is the subject of this great *c.* 1867 photograph, an image rich with details of a lost age. Note the wagon factory, partially obscured by the bank building at left, David Fitch's grocery and ship chandlers at right, and the men posing in the doorway and ground-floor window of the insurance office.

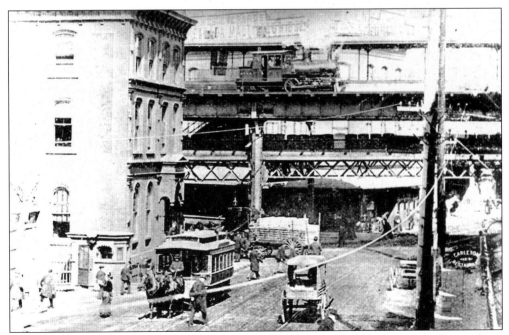

This *c.* 1890 image shows the busy intersection of Broadway and Kent Avenues. The tracks in the background are those of the old Brooklyn railroad's elevated spur, which brought commuters to and from the Manhattan ferry at the foot of Broadway. Note the oval sign for the Carlton Restaurant at the lower right.

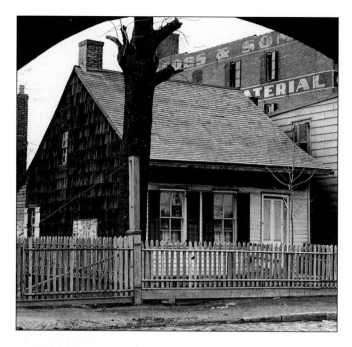

The Cochrane house was dwarfed by the bustle and big buildings on Flushing Avenue in the years before it was demolished. Forlorn but still neat in this *c.* 1910 lantern slide, it is surrounded by a rustic picket fence, a factory to its rear.

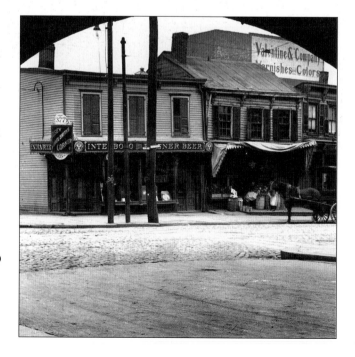

With its horse-drawn wagons and wood-frame houses, Williamsburg resembles the old American West in this *c.* 1900 lantern slide image. At left is Michael Smith's Cosey Corner, a saloon at 379 Graham Avenue; the store to its right appears to be a grocery. The Valentine and Company paint and varnish factory stands at rear right.

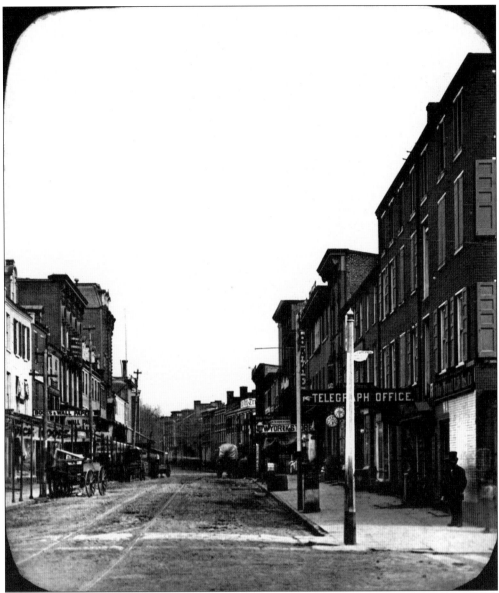

This extraordinary *c.* 1870 lantern slide captures the view looking south along Bedford Avenue at South Ninth Street. Note the fine brick buildings, the old advertising signs, hitching posts, and the top-hatted gentleman at the lower right.

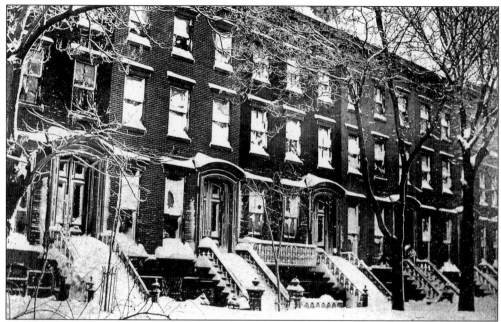

The mighty Blizzard of 1888 was well recorded by photographers of the day. According to its caption, this image shows, at left, the elegant house of L. P. Nostrand (at 149 Taylor Street) a day or two after the storm. The Nostrand house has since been replaced by an apartment building, but the individual dwellings to the right still stand. Today, Taylor Street is in the heart of Williamsburg's Hasidic district.

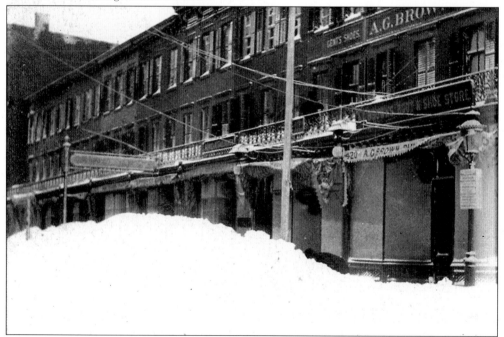

After the blizzard, the A. G. Brown Boot and Shoe Store, at 420 Bedford Avenue just south of Broadway, stands behind a mountainous snowdrift. Note the sign reading, "Gents Shoes" on the front of the building. The caption credits the image to the Brooklyn Academy of Photography.

14

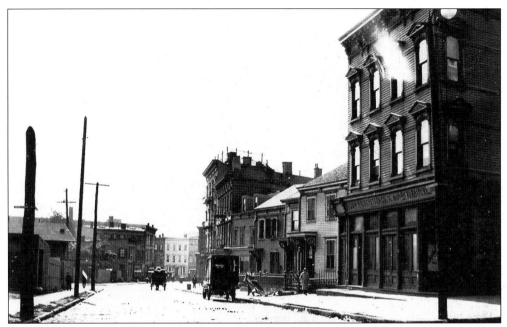

Bushwick Place, a small street in East Williamsburg, is the subject of Eugene Armbruster's interesting 1923 photographic study. Note the frame houses at center, their fronts angled to the street, in an urban design used in the 1830s and 1840s. The caption records that the newer house at right, with a ground-floor furniture dealer, was owned by "Senator Lindsay."

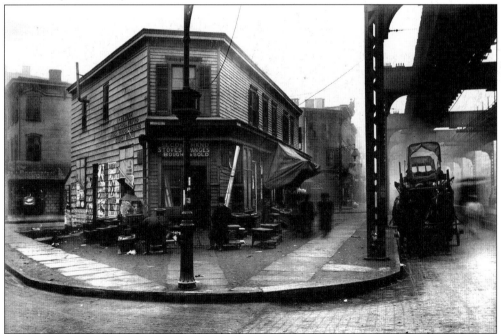

The curious frame structure built to fit the minuscule, irregular block at Moore Street and Broadway in East Williamsburg was occupied by I. Friedman's secondhand stove shop when W. J. Mullen took this photograph in January 1906. Although the house is gone, the elevated subway still roars and rattles above Broadway.

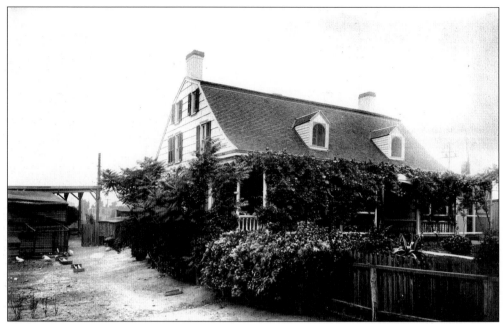

This photograph, taken *c*. 1900, captures the look of the farming communities of old Brooklyn. The very beautiful Dutch Colonial farmhouse stood just off Flushing Avenue, an ancient road that was once dotted with many old houses. Note the vine-covered picket fence and the chickens pecking in the dirt at left.

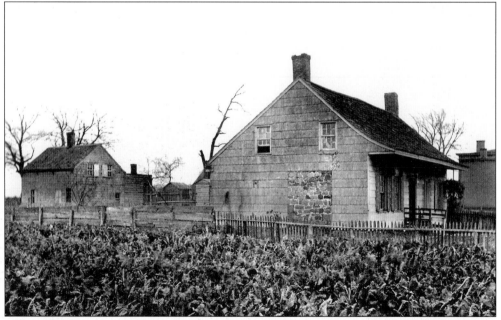

Williamsburg's urban development moved eastward from the river, with rural backwaters holding on as late as the 1920s. This 1923 image shows a Dutch farmhouse, with its characteristic sloping roof, at Bushwick Avenue and Debevoise Street. Even today, some of East Williamsburg's quiet residential sections seem a world away from the energy and urbanity of Broadway and Bedford Avenues.

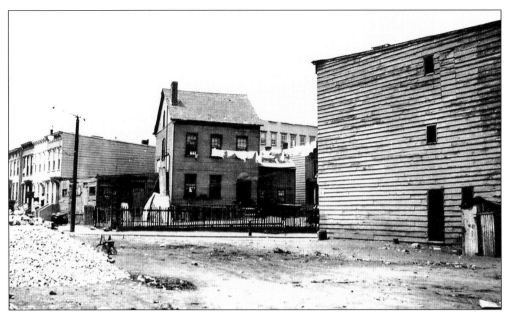

Armbruster captured another scene of change in the East Williamsburg of 1922 in this photograph of an old frame house at Woodpoint Road and Skillman Avenue surrounded by newer homes. Note the odd angle of the house in relation to the unpaved street. The caption on the back indicates that the land was owned in 1855 by Andrew Conselyea, for whom a nearby street is named.

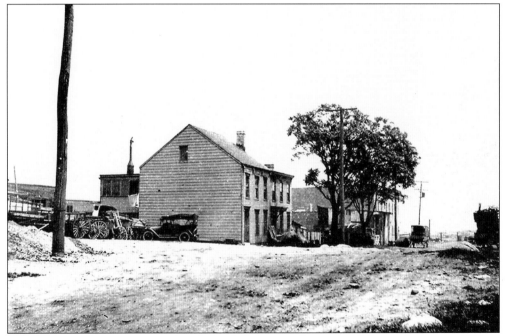

This photograph's caption reads, "Gabriel Debevoise born in 1775 was living in 1852 at Bushwick southside of Wither St. . . . east of Morgan Ave." It does not state whether the frame house at center is that structure, but Armbruster's 1922 image shows property that had belonged to Debevoise. Wagon wheels lined up behind the house indicate the area was still semi-rural.

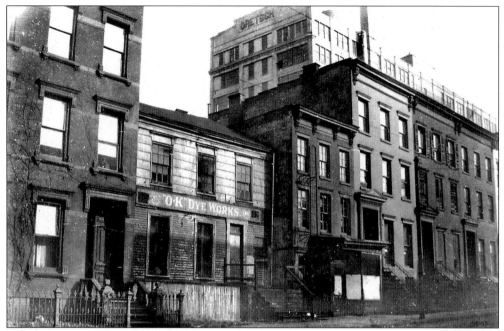

The O. K. Dye Works occupied the decrepit frame house at 42 South Eighth Street (dating from the 1820s or 1830s), shown in Armbruster's 1923 photograph. Although the buildings in the foreground have disappeared, their lively architectural variety remains typical of Williamsburg's streets. The Gretsch Building, a musical-instrument factory that is now undergoing renovation into luxury lofts, looms behind.

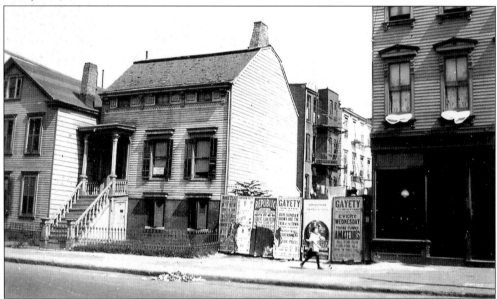

Williamsburg's streets were once lined with interesting structures like this little 1830s house, which stood on Bushwick Avenue south of Grand Street. The disproportionate stairway and portico were grand Greek Revival details tacked onto the house's otherwise modest Federal form. Architectural curiosities intrigued Armbruster, who fortunately preserved them in photographs such as this one, shot in 1923.

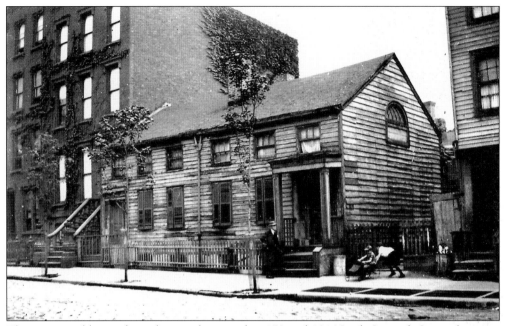

The century-old twin frame houses that stood at 179 and 181 North Seventh Street, between Bedford and Driggs Avenues, showed age when Armbruster photographed them in 1929. The house at right, presumably 181 North Seventh, had a handsome half-round window set into the side of its upper story. A brick house occupies the site today.

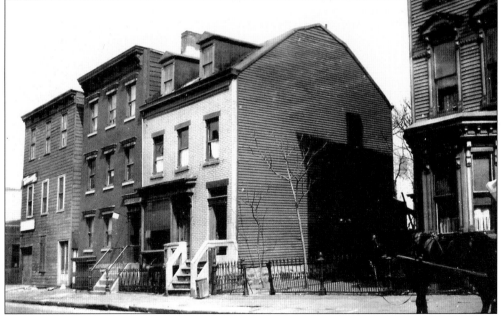

Armbruster may have been trying to record all of downtown Williamsburg's Federal-style houses in March 1929, when he took this photograph on North Fourth Street and those shown on pages 20 and 21. The houses have similar shapes and the refined detailing typical of the Federal period. The large picture window on the ground floor suggests that the building served as a shop as well.

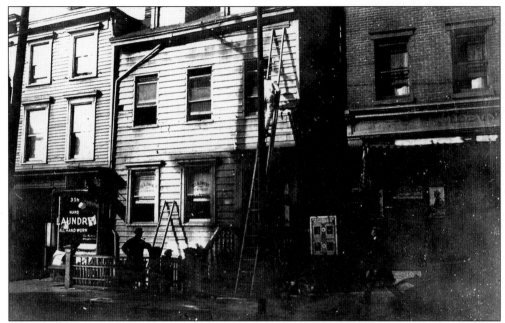

According to the caption on this image, this Federal-era house at 354 Bedford Avenue was "Geo. A. Owen 14th Assembly Dem. Club" when Armbruster photographed it in November 1923. The name of the organization can be seen on the first-story windows. Note the painters at work on the exterior and the laundry next door. The structure has since been demolished.

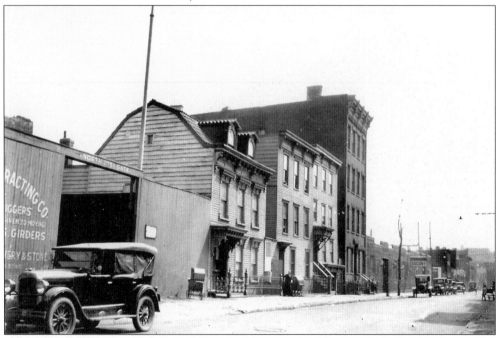

The graceful, gambrel-roofed form of this wood-frame Federal house enriched the streetscape of North Third Street, between Bedford Avenue and Berry Street, when photographed by Armbruster in March 1929. Some structures from the first half of the 19th century still stand in this part of Williamsburg, but most have been altered beyond recognition.

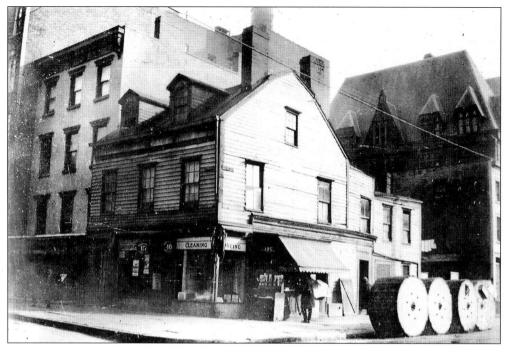

This fine house stood at the northeast corner of Bedford Avenue and South Third Street. A dry cleaner occupied the ground floor, and a newspaper dealer operated from the tiny stand on the South Third Street side when Armbruster took this photograph in 1923.

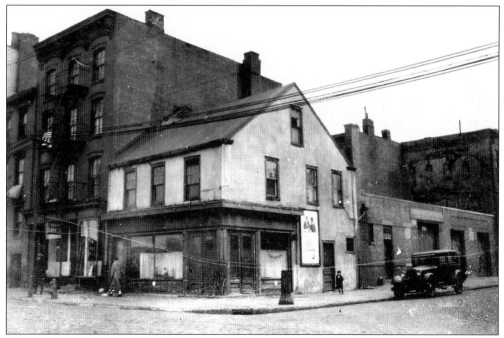

Kent Avenue has become more bleak since Armbruster photographed the little Federal house at North Sixth Street in March 1929. The caption on the reverse notes that the building was stuccoed; now sided with aluminum, the house still faces the East River as a remarkable survivor.

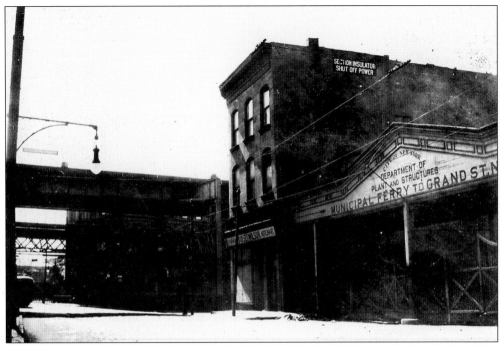

The terminal for the Grand Street ferry stands derelict in this 1928 image by Armbruster. The building, located at Kent Avenue just north of Broadway, had been unused since 1909, when the service ceased operating. The Williamsburg Bridge, the opening of which in 1903 caused the ferry's demise, dominates the left side of the image; the tracks for the elevated train run below and parallel to the bridge.

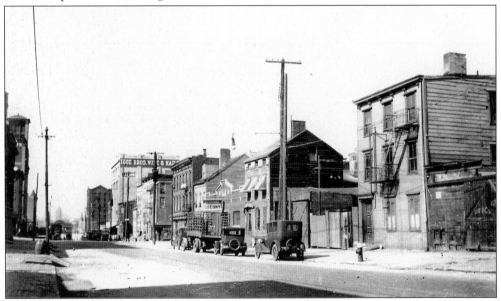

The two pitched-roof structures in this October 1928 photograph of the north side of Metropolitan Avenue, between Wythe Avenue and Berry Street, were built before 1850 but have not survived. The Manhattan skyline can be seen in the distance; Metropolitan Avenue, one of old Williamsburg's most important streets, is remarkably quiet in this midday view by Armbruster.

These tiny frame houses stood on Flushing Avenue, just west of Bushwick Avenue, when Armbruster photographed them in September 1923. The caption notes that the one on the left was "owned by Conselyea," the name of an old and important local family. An enormous housing project occupies the site today.

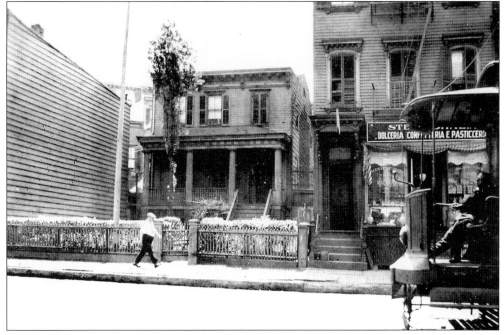

Old and older mingle in this remarkable 1922 Armbruster photograph of the Debevoise House, at 800 Flushing Avenue. At right, a trolley car, its driver clearly visible, passes in front of an Italian pastry shop. The frame house at center has been replaced by a brick church that is also set back from the street; the buildings on both sides still stand, though altered.

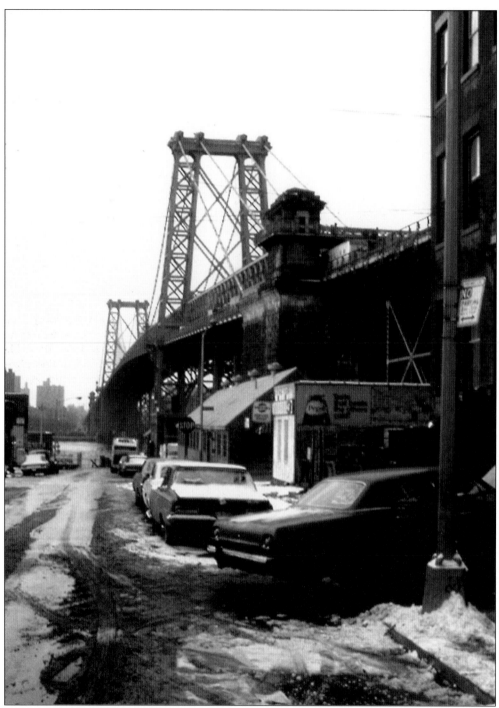

The Williamsburg Bridge looms ominously above the modest structures lining South Sixth Street near Kent Avenue, with the East River and the Lower East Side of Manhattan in the background. Note the subway passing the anchorage tower just right of center. This powerful image, which dates from the mid-1970s, successfully captures the desolation of the Southside in Williamsburg's darkest days.

Two
THE BRIDGE

Envious of the convenience and economic benefits bestowed by the Brooklyn Bridge on Brooklyn Heights and downtown Brooklyn, Williamsburg residents agitated for a second span upriver. Their wish was granted when the Williamsburg Bridge opened on December 19, 1903. Unlike its older sibling, the massive steel structure, designed by engineer Leffert L. Buck, has never been regarded as beautiful. The changes it wrought on Williamsburg were enormous, and often ugly, too.

The six or so ferry lines that plied the East River between Williamsburg and Manhattan went out of business within a few years of the bridge's opening. Tens of thousands of poor Jews, mostly immigrants from Russia and Poland, flooded Williamsburg across the bridge's pedestrian walkway to escape the slums of the Lower East Side. In its early years, the walkway, which was wide enough for pushcarts, was so crowded with peddlers transporting their wares to and from Manhattan that one newspaper dubbed it "the Jews' highway." Unhappy with the exotic newcomers, many of the neighborhood's German and Irish families moved away, as landlords eagerly met the needs of the booming rental market by building tenement apartment houses and converting old single-family row houses into multiple dwellings. Williamsburg soon became badly overcrowded.

The photographs that follow show the bridge in various guises. Some early shots, especially those taken from a distance, can be lyrical. Postcard images celebrate its brutal design, which has been enlivened a bit recently by new walkways of brightly painted steel. The bridge appears as an early example of 20th-century architectural gigantism, indifferently dwarfing the old buildings of wood, brick, and stone that lined Williamsburg's riverside streets.

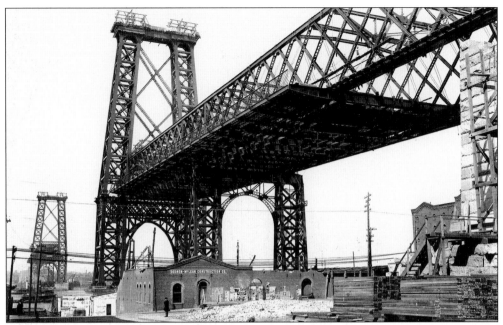

Arthur Wilmott chronicled the bridge's construction in this *c.* 1900 photograph and the two that follow. This picture, taken from nearly the same spot as that on page 27, shows the towers and the massive truss supporting the deck. Note also the brick shed underneath, which housed the Degnon-McLean Construction Company, builders of the bridge.

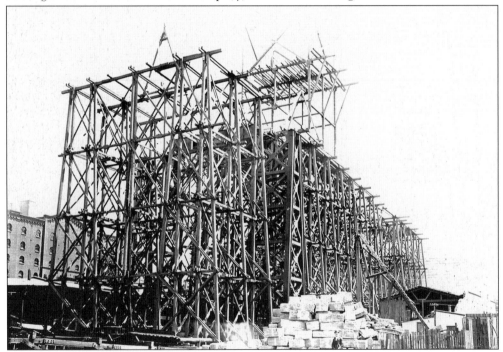

This interesting image reveals the scaffolding, most likely for the anchorage towers. Note the pile of cut granite at the bottom, just right of center. The delicate-looking scaffolding gave little sense of the massive steel bulk of the bridge that would eventually emerge.

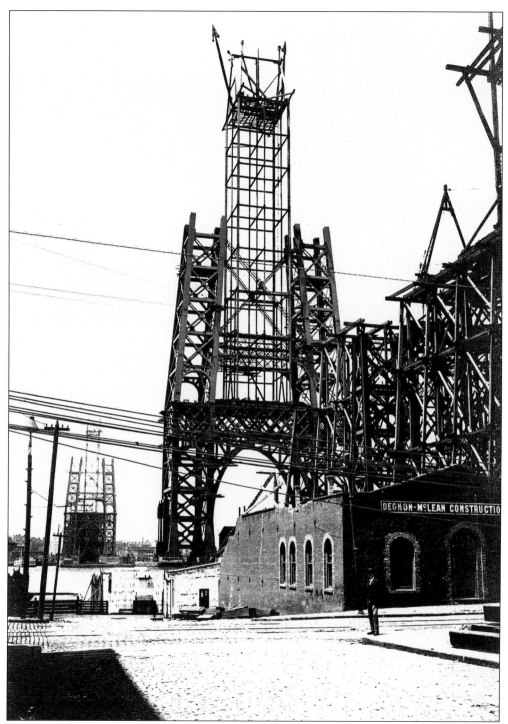

The towers, shown here under construction, bore a faint resemblance to the Eiffel Tower, the 1889 structure that in its time was a major showpiece of steel engineering. There is also a good view of the Degnon-McLean shop below. The Williamsburg Bridge took about half as long to build as the Brooklyn Bridge but, unlike its older sister, has never been regarded as an aesthetic success.

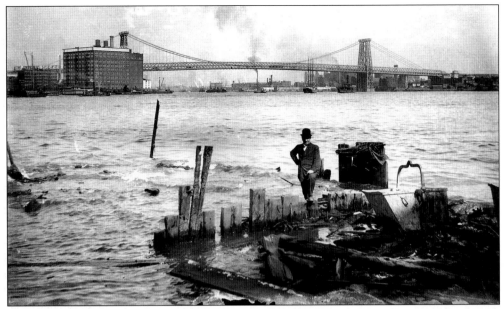

The caption of this unusual glass negative image is confusing, describing the 1905 photograph as "Brooklyn Sewer Construction" and "Williamsburgh Bridge looking north." Its orientation does indeed appear to be from a point much closer to the Manhattan shore south of the bridge, with Corlear's Hook protruding at left and the industrial buildings of the Williamsburg waterfront behind the bridge tower at right.

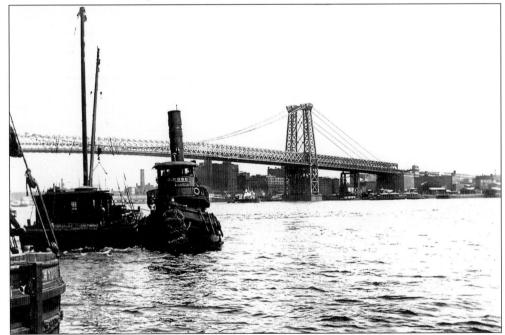

This July 1926 view of the bridge was taken from the Manhattan shore; Armbruster may have purchased it. The image is framed so casually that part of a boat is visible at left, but the bridge's Manhattan tower is left out; nevertheless the image establishes an immediate and intense feeling of the riverfront.

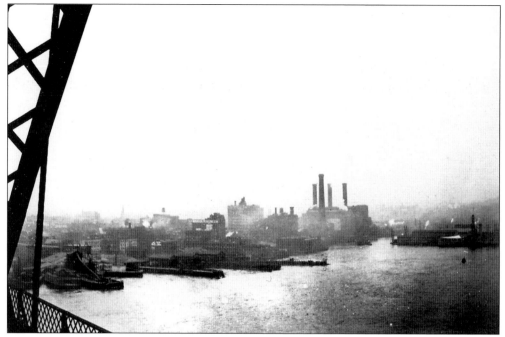

This view and the one following, taken from the walkway of the bridge looking south, are dominated by the plants that lined the Southside's waterfront. Both are by Armbruster in 1922. The buildings on the shore curving to the right are those of the Brooklyn Navy Yard.

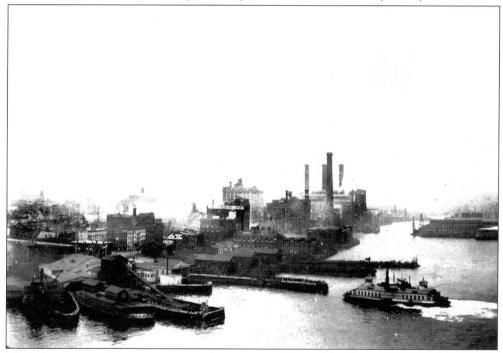

Much the same as the previous view, this image is enlivened by the presence of what appears to be a ferry steaming toward its terminal. The original Williamsburg ferries went out of business in 1909, but in 1922, one was revived for a few years under municipal ownership.

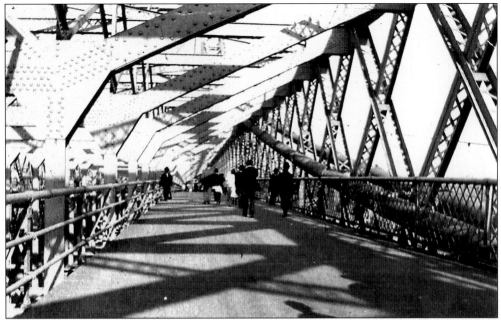

Pedestrians cross the bridge during its early years in this image highlighting the bulky structure of the truss. Less popular with pedestrians now than either the Brooklyn or Manhattan Bridges, the Williamsburg Bridge's walkway is often closed. It was, however, the only one of the three built with a pathway for bicycles and pushcarts.

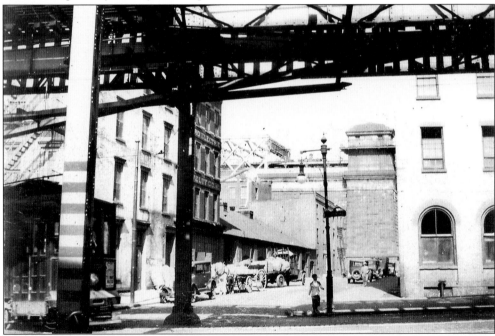

Dunham Place, a one-block street in the shadow of the bridge, is the subject of this c. 1925 Armbruster study. The anchorage of the Williamsburg Bridge looms in the background, and the tracks of the elevated train that ran over Broadway frame the foreground. Note also the Broadway streetcar at left. Today, Dunham Place looks much the same.

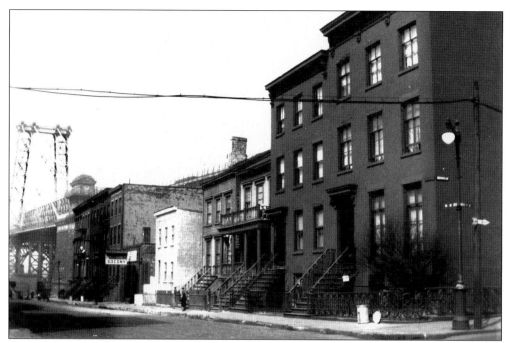

This photograph, taken *c.* 1925, is a gentler version of the later image on page 24. Here, the bridge provides a graceful visual counterpoint to the old houses that line South Sixth Street west of Berry Street. Most of these still stand today.

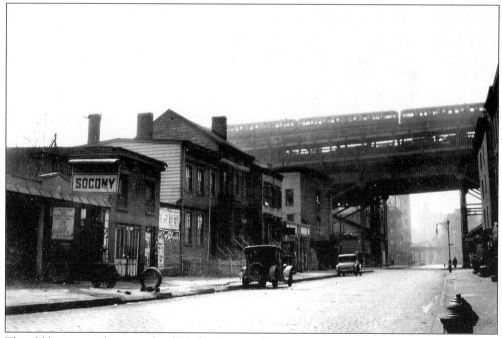

The old houses on the east side of Wythe Avenue, between South Fourth and South Fifth Streets, are the subject of this 1929 Armbruster image. The two-story building with the Socony sign still stands. The structure of the Williamsburg Bridge cuts horizontally across the low streetscape.

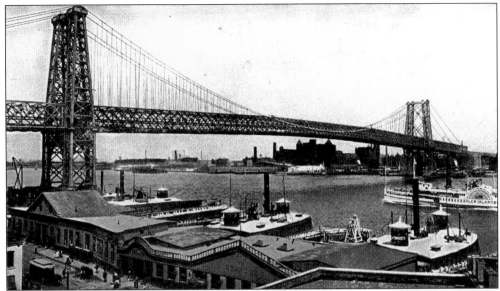

Postcards were once a popular medium for brief, informal notes. This *c*. 1905 postcard image and several that follow were taken from Lower East Side rooftops. The massive bulk of the sugar refinery, visible under the center of the bridge, is the major landmark on the Williamsburg side of the river. Note the ferry slips with their docked boats, doomed by the convenience offered by the East River bridges.

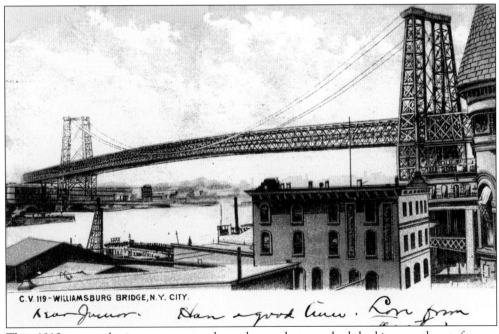

C.V. 119 - WILLIAMSBURG BRIDGE, N.Y. CITY.

This 1910 postcard view appears to have been photographed looking southeast from a Manhattan rooftop, then heavily retouched. The identity of the large, horizontal structure under the bridge on the other side of the river is unclear.

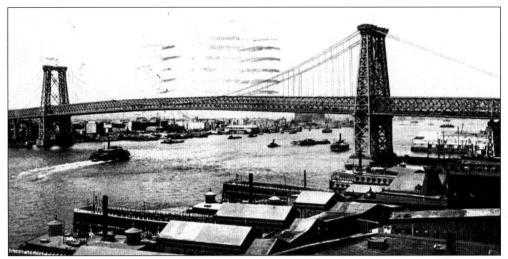

This 1906 card offers a good view of the Williamsburg Bridge, as well as the Brooklyn and New York waterfronts. Like many old postcards, it also offers a glimpse into the life of both recipient and sender. The handwritten message reads, "Left the Folks all well at home. Uncle Ed."

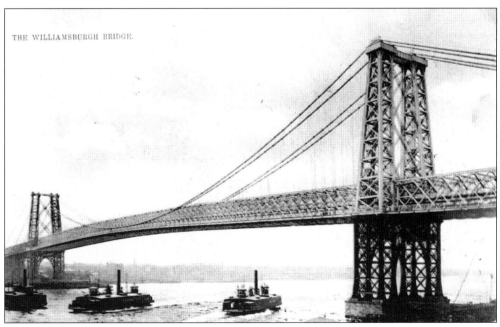

THE WILLIAMSBURGH BRIDGE.

The angle from which this 1905 postcard was taken makes this image less satisfying to the eye than the previous, but it does provide a good sense of the heavy ferry traffic that once crowded the East River. A careful look reveals that the three boats in view passed each other very closely.

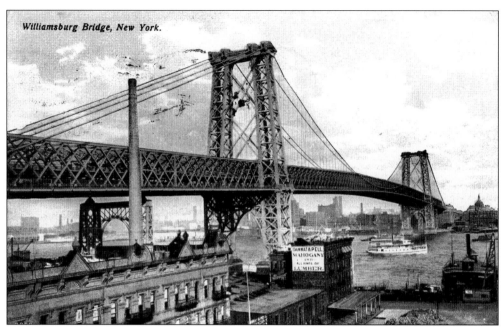

Williamsburg Bridge, New York.

This 1908 postcard, addressed to Master Albert Scamman of Phillips, Maine, carries the following message: "Have seen this Bridge but didn't go over it. One building here, almost completed, is to be 52 stories high. It makes my neck ache to look at it. Love to all—from Aunt Mabel." The dome of the Williamsburgh Savings Bank is visible across the river at the far right.

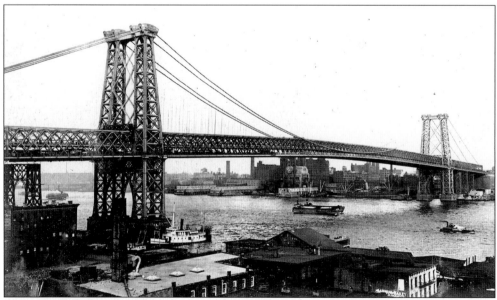

The feeling of this *c.* 1930 postcard image is no longer celebratory. Barges and smaller river traffic have replaced the ferries. The tenements and commercial structures of the Lower East Side look drab; the bridge seems grimy and unattractive. Curiously, the base of the Manhattan tower is photographically duplicated at the lower left.

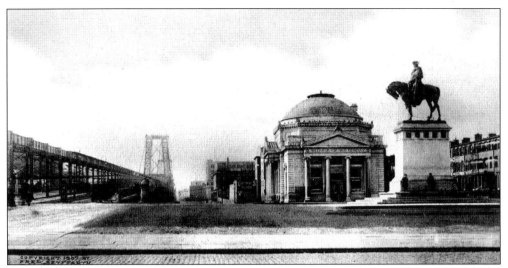

The grandeur of the Williamsburg Bridge Plaza is the subject of this 1907 postcard, which also shows the domed Williamsburg Trust Company, right of center, and Henry M. Shrady's equestrian statue of George Washington at right. Today, the plaza is a tight tangle of roads that is hostile to pedestrians.

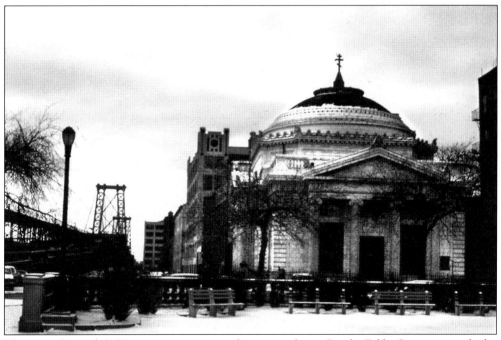

This moody mid-1970s winter view to the west along South Fifth Street toward the Williamsburg Bridge and the former Williamsburg Trust Company captures a rugged urban landscape. The old bank building, its dome topped with an eastern orthodox cross, has been converted to the Holy Trinity Cathedral of the Ukrainian Autocephalic Church.

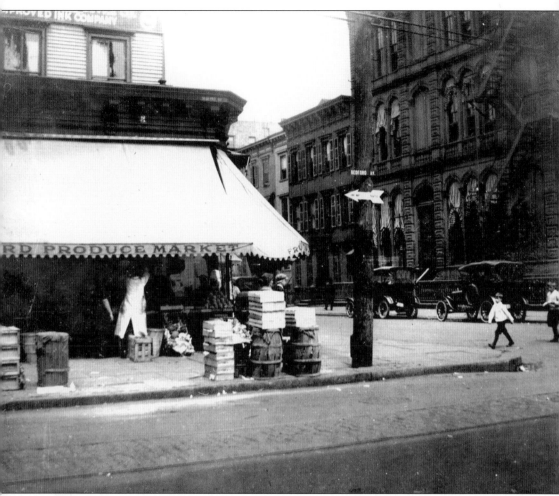

The period before 1855, when Williamsburg was incorporated into the city of Brooklyn, is recalled in this 1923 Armbruster photograph. The old building at center, on South Second Street just west of Bedford Avenue, once served as Williamsburg's city hall. The image is enlivened by the aproned grocer under the awning of the Bedford Produce Market and the three knicker-clad boys crossing South Second Street.

Three

STREET LIFE

Most of the images in this chapter were taken in the mid-1920s by Eugene Armbruster, a photographer, genealogist, and antiquarian who chronicled the Brooklyn of the early 20th century. The photographs are uneven in quality. Most were shot from middle distance and similar, somewhat dull, angles. A lamppost splits what might have been a decent photograph down the middle, and some pictures lack people to lend life and scale. Even with its flaws, though, the Armbruster Collection offers a clear look at a world that is gone forever, yet unmistakably familiar to New Yorkers and to city dwellers generally. In these images, we see life in the streets of Williamsburg, which was not vastly different 75 years ago. We are shown busy markets and restaurants, and quieter blocks lined with old houses. People walk and shop, children play, and cars—beautiful, old cars—hurtle down streets. Armbruster captured a time before cars and trucks had completely replaced horse-drawn wagons. In none of the images is anyone posed or obviously conscious that a photograph is being taken. In their artlessness, Armbruster's images give us perhaps a more vivid feel for the street life of Williamsburg than more studied compositions could provide.

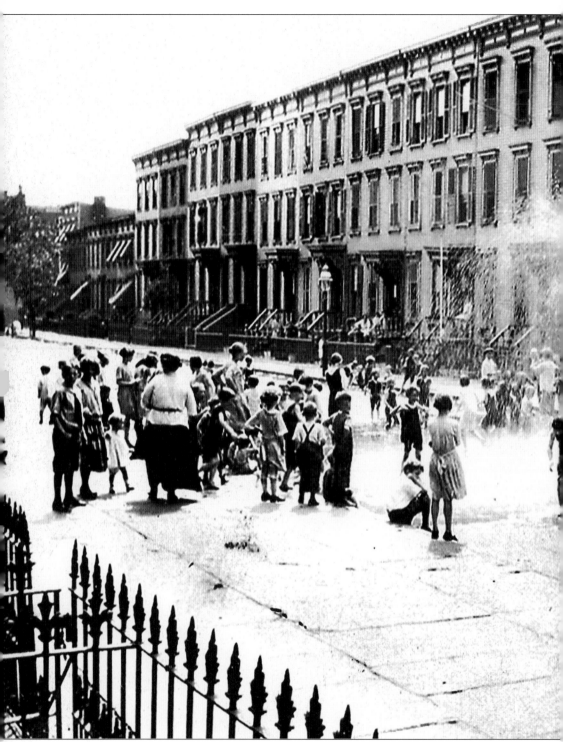

As evidenced by the recent image on page 127, this block of Lynch Street has changed little since *c.* 1915, when this timeless urban image was taken. The handwritten caption reads, "Lynch st Bklyn on a hot day." Today, this section of South Williamsburg is a mix of Hasidic

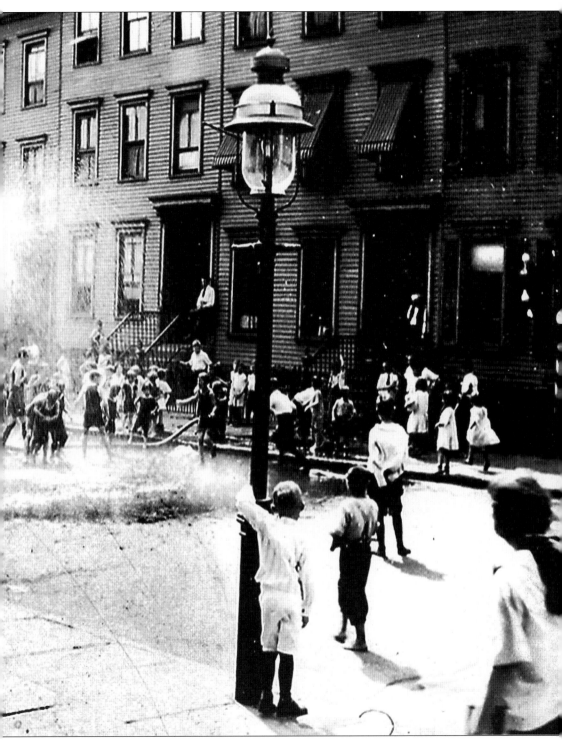

and Hispanic residents. The south side of the street, from which both photographs were shot, is now occupied by Public School (PS) 380.

BROOKLYN EAGLE POST CARD, SERIES 19, No. 110.

MARKET PLACES ON MOORE STREET.

In the early 20th century, the *Brooklyn Daily Eagle*, the borough's hometown newspaper, issued postcards of local landmarks and curiosities. This one shows pushcarts on Moore Street in East Williamsburg, today part of the area's Hispanic heartland. The *Eagle*, once edited by Walt Whitman, ceased publication in 1955 but has since been replaced by a new paper using the venerable name.

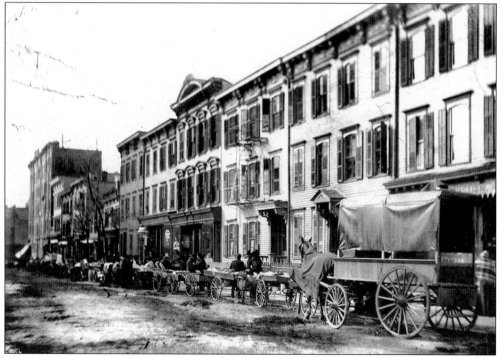

This charming *c.* 1900 image shows what appears to be an open-air market along Cook Street. The old row houses make a fine backdrop to the horse-drawn wagons and pushcarts. Cook Street runs parallel to Moore Street, two blocks to the south.

40

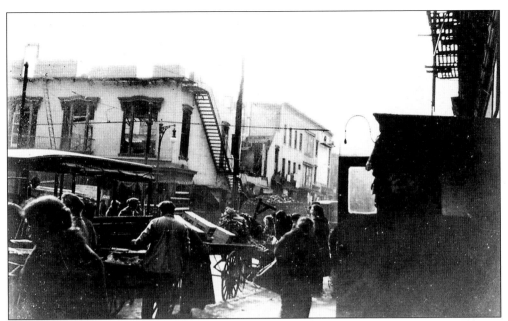

Here, Armbruster catches the animation of the pushcart market outside the Unique Theatre, at Grand and Havemeyer Streets. The building in the background, apparently the theater, suffered a disastrous fire not long before this otherwise lively photograph was taken in 1923.

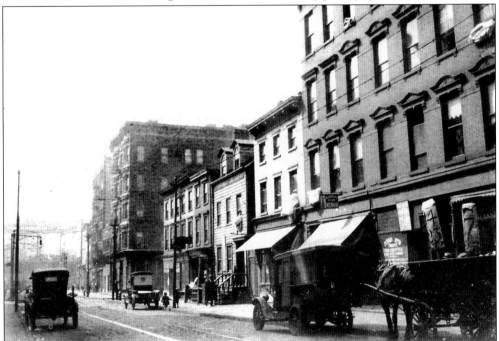

Horse-drawn carts and automobiles still shared Williamsburg streets in March 1929, when Armbruster took this view, looking down Bedford Avenue from South Fourth Street. A Federal-style house, also shown on the top of page 20, stands in the middle of the block. The sign in the window of the shop just above the horse at right is in Yiddish, reflecting the area's large Jewish immigrant population.

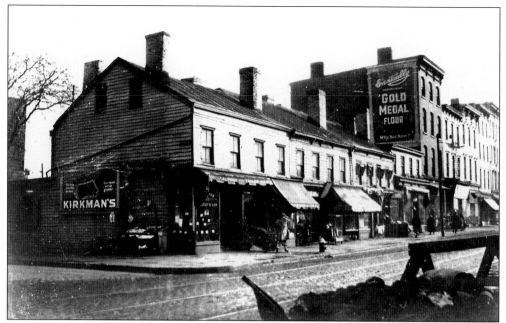

Small shops occupied the old frame houses on Grand and Rodney Streets shown in this 1923 Armbruster image. Today, the Brooklyn-Queens Expressway runs where this fine row once stood. Note the fruit stand to the right of the Kirkman's sign and the billboard advertising Gold Medal flour in the four-story brick building at right.

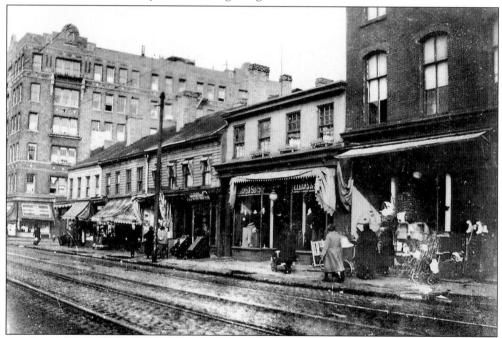

Armbruster evidently walked down Grand Street, photographing the previous image and then this one. The informative caption indicates that the "first little house on left (corner) was Mahlor's bakery about 1870 & the fourth or last of the little houses was Hagenbacker's clothing store about that time . . . Williamsburgh . . . Nov. 1923."

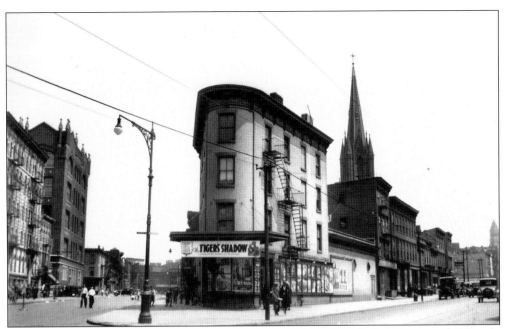

This interesting building on the triangular block is located at Flushing Avenue and Whipple Street; the "Tiger's Shadow" advertised by the ground-floor shop remains a mystery. The four-story commercial and residential structure shown in this *c.* 1925 image has been cut in half horizontally, is now unoccupied, and appears to be a candidate for demolition.

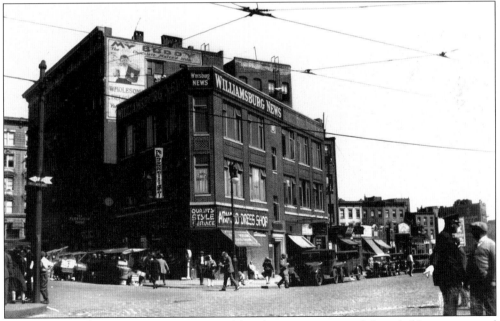

Another triangular block, this one created by the intersections of Grand, Havemeyer, and South Third Streets, was home in 1922 to Arnold's Dress Shop and the *Williamsburg News*. The street at left is also lined with pushcarts, and the apartment house behind carries a billboard advertising My Buddy Chocolate Malted Milk. The little commercial building still endures, with the Brooklyn-Queens Expressway as its overwhelming neighbor to the right.

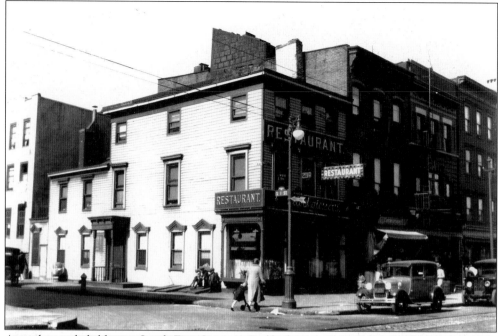

A mother and child cross South First Street at Bedford Avenue. Handsome signs advertise the restaurant occupying the ground floor of the frame house on the corner, while beautiful cars line the street in this *c.* 1925 image.

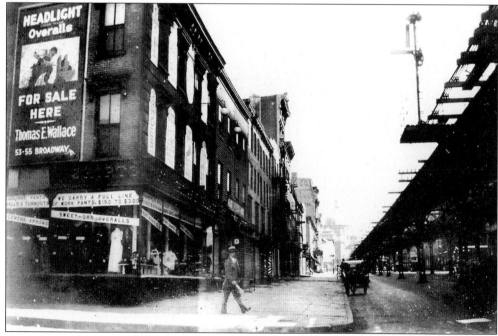

Headlight overalls were available at Thomas E. Wallace's clothing store, according to the sign on the building at 53 Broadway, at the corner of Wythe Avenue. Another sign in the window reads, "We carry a full line of work pants—$1.50 to $3.00." The elevated tracks seem to point at the domed Williamsburgh Savings Bank down the street in Armbruster's symmetrical 1928 image.

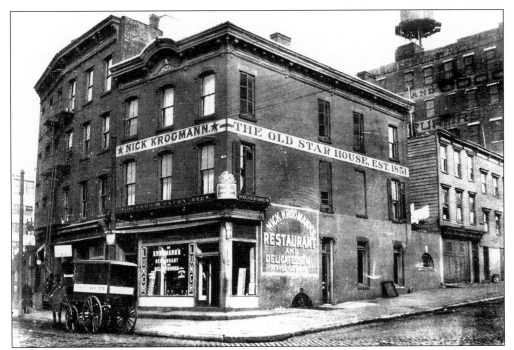

Nick Krogmann's Restaurant and Delicatessen had succeeded the Old Star House (established in 1857, according to the sign) in this attractive 1875 building on Kent Avenue at Clymer Street. The handwritten caption of this 1923 Armbruster photograph asks, "Did the Old Star House originally occupy the Remsen farmhouse?"

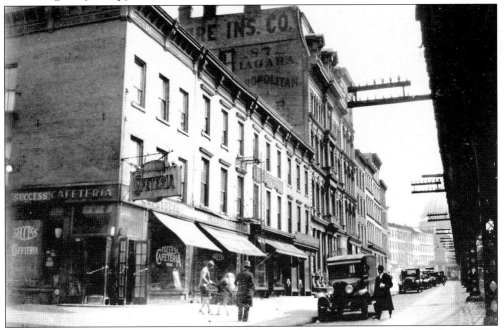

The Success Cafeteria operated at 97 Broadway on the busy corner of Berry Street. The pedestrians in front of the restaurant are uniformly well dressed. Note the power lines attached to the structure of the elevated train at right.

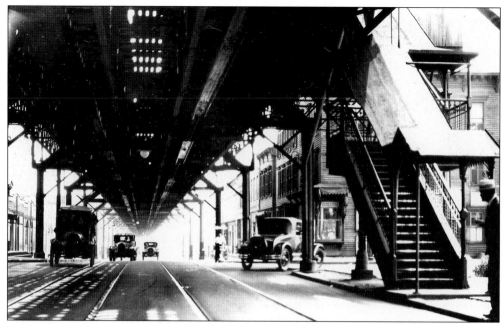

The patterned shadows of Broadway under the tracks of the elevated train are caught in this *c.* 1920 photograph. The cars and trolley tracks in the street show two additional forms of transportation, while the pedestrian at the far right peers cautiously at traffic, which would today be considered light for this busy street.

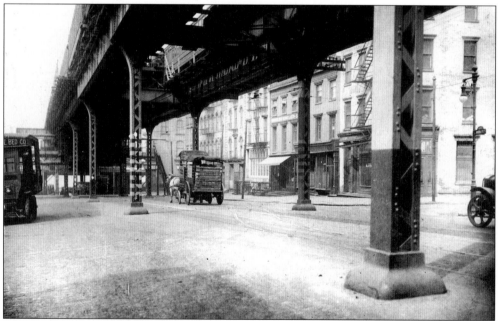

The Kent Avenue station of the old Broadway el is visible in the distance at left in this *c.* 1915 image. The station deposited pre–Williamsburg Bridge commuters at the Grand Street ferry, defunct by the time this photograph was taken. In addition to the el and the ferry, three other vehicles are operating: a delivery truck at far left, a horse-drawn truck at center, and an automobile at far right.

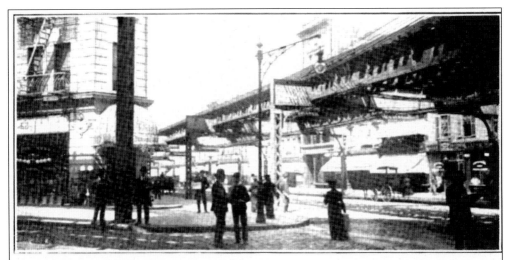

JUNCTION BROADWAY AND MYRTLE AVENUE.

The elevated tracks and handsome buildings at the intersection of Broadway and Myrtle Avenue make a fine background for strollers (one, at right, reads his newspaper) in this *c.* 1905 *Brooklyn Eagle* postcard image.

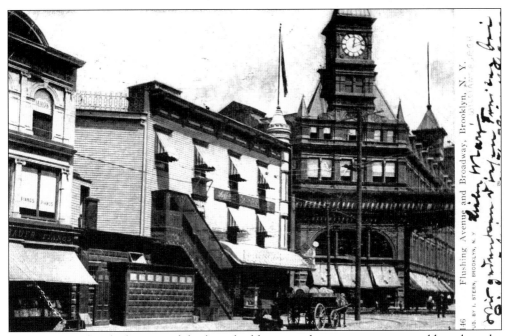

According to the clock tower of the large building at right, it was just past midday when the image for this 1911 postcard was shot. The ornate building, which appears to have been a department store, stood at the intersection of Broadway and Flushing Avenue in southeastern Williamsburg. Note the el tracks on Broadway and the handwritten message.

This modest structure at 342 Bedford Avenue was the former home of the Williamsburgh Hospital when Armbruster photographed it in March 1929. The ground-floor shops, a pharmacy with Polish and Russian signs, and a kosher butcher show how dense the Williamsburg melting pot had become.

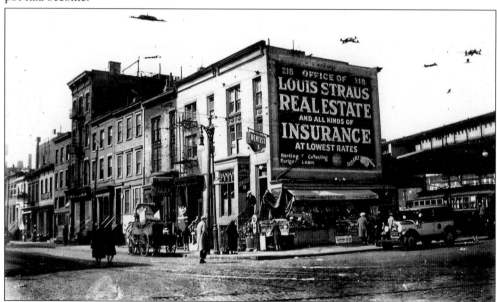

This March 1929 Armbruster image reveals the shops, businesses, and traffic at South Eighth and Roebling Streets. The caption reports that the structure housing the real estate and insurance offices of Louis Straus is a "former church building." Gothic flourishes can be seen in the windows. Note also the elevated subway in the background at right.

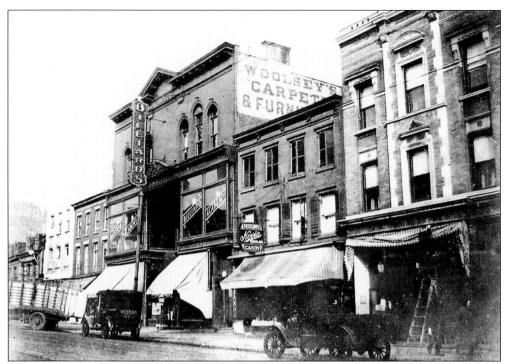

Shops line the north side of Grand Street, between Bedford and Driggs Avenues. The caption informs us that Woolsey's carpet store, which once occupied the building at center, had "dissolved [in] 1909." A billiard hall had taken over the second floor when Armbruster took this photograph in 1923. Kestler's candy store, at center, sold Novia brand chocolate. Today, the structure is occupied by residential lofts.

This 1923 Armbruster image of houses and a butcher shop at Humboldt and Scholes Streets gives a good sense of daily life in Williamsburg. An important part of what makes the Williamsburg streetscape so attractive is the modest scale of the buildings, which persists in most of the neighborhood.

The twin houses at center display the shrewdness of a builder of the 1830s or 1840s who squeezed two dwellings under one roof. In contrast, the late-19th-century developer of the structure at right (also wood framed) planned for only a few families in his little apartment house. In Armbruster's 1923 view of Humboldt Street just south of Conselyea, 20th-century density is visible at left in the distance.

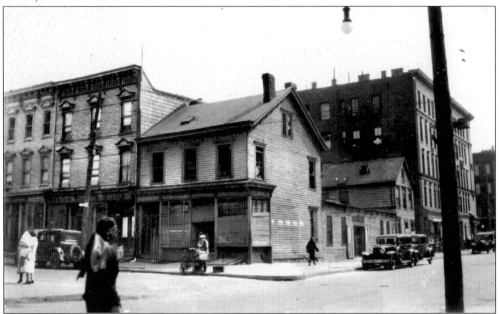

The old houses at the corner of Humboldt and Scholes Streets in East Williamsburg are the subject of this March 1929 study by Armbruster. The immediate area appears to have been predominantly African American; today it is chiefly Hispanic.

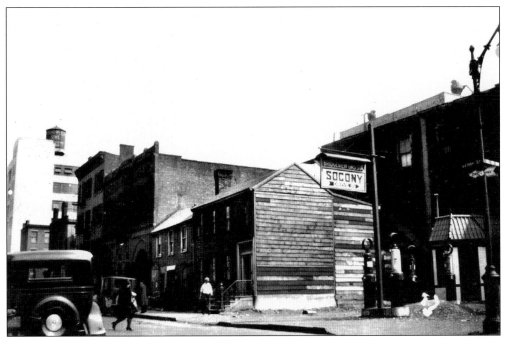

This March 1929 photograph of the Bridgeview gas station on Berry Street at South Fifth deserves close study. Note the old gas pumps and the Socony sign, the frame houses from another era at center, and the automobiles. The day must have been mild, as the man wearing the cap at center is coatless.

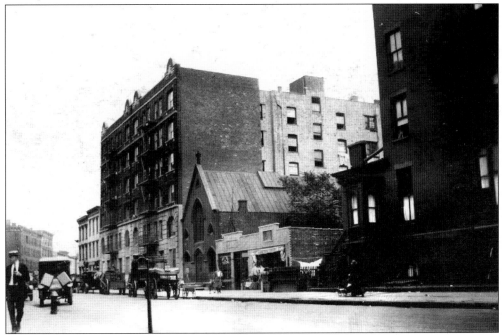

The small building resembling a church was the Partridge Memorial Chapel, a funeral home on the south side of Division Avenue, just east of Bedford Avenue. The chapel is now gone, but the other buildings in Armbruster's 1922 photograph have survived.

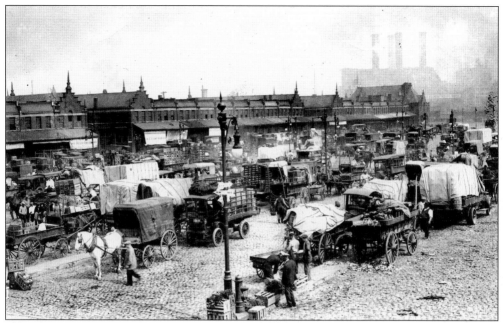

The Wallabout Market was a wholesale produce exchange that operated from 1890 until 1942 in these gabled structures at Clinton and Flushing Avenues, next to the Brooklyn Navy Yard. The colorful, raucous scenes that made New York's wholesale food markets such beloved institutions are caught in this late-19th-century image.

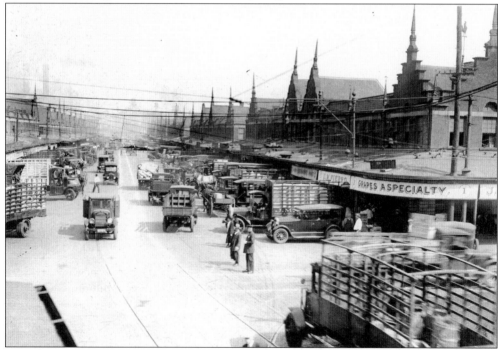

Many cars and trucks—but not a single horse-drawn wagon—are visible in this photograph of the Wallabout Market, taken about 25 years after the one previous. The sign of fruit vendor J. M. Fierro, in the right foreground, advertises, "Grapes a Specialty."

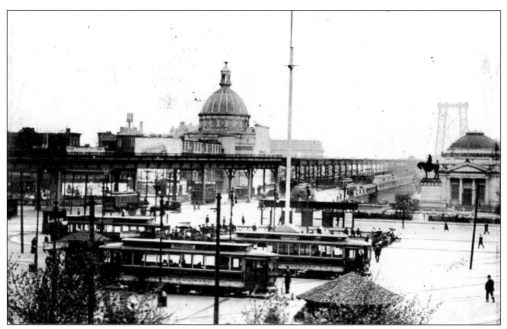

The Williamsburg Bridge Plaza was once spacious enough to serve as a major streetcar hub, as seen in this c. 1920 view. Three of Williamsburg's great landmarks are also visible: the impressive Williamsburgh Savings Bank at center, the equestrian statue of Washington, and the Williamsburg Trust Company at right.

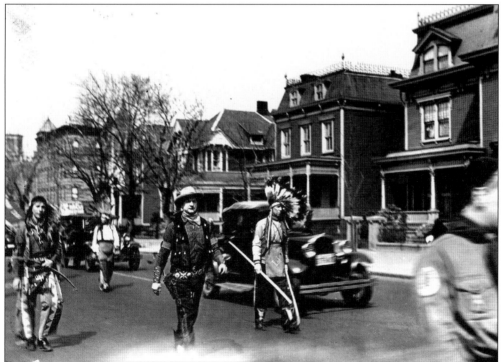

Photographer F. Paul D. Huseman photographed parents dressed as "cowboys and Indians" in a March 1937 Boy Scout parade down an unidentified Williamsburg street.

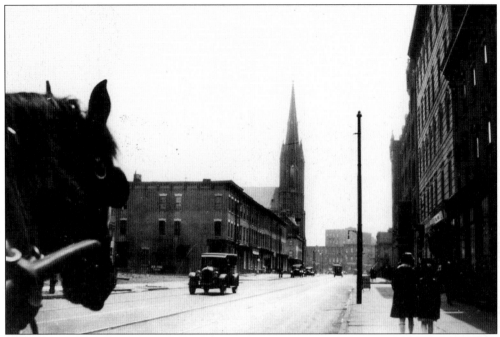

Armbruster gives us a dray horse's view of Gerry Street near Flushing Avenue in South Williamsburg. The horse is outnumbered by cars, and the children on the sidewalk at right appear well dressed in this offbeat image from May 1929.

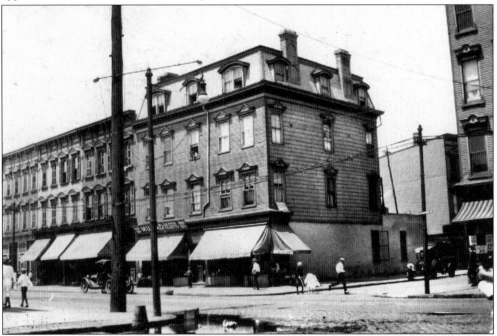

Now covered with aluminum siding, Abraham Vandervoort's clapboard mansion still stands on Flushing Avenue and Vandervoort Place, at the border of Williamsburg and Bushwick. Although Armbruster's portrait of the old house on a warm day in 1922 is slightly off-kilter, it still gives a good feeling for life on the early-20th-century Brooklyn street.

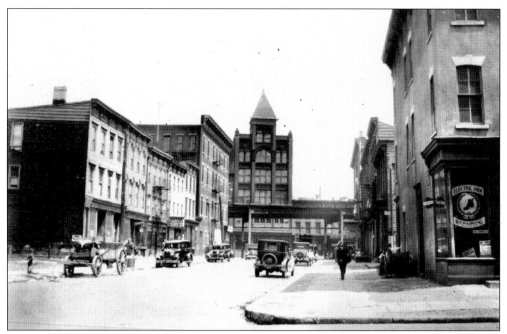

This interesting May 1929 view looks north along Bartlett Street toward Broadway, on which the el ran and still runs. The South Williamsburg neighborhood had a shop advertising "Electric Shoe Repairing," seen at right.

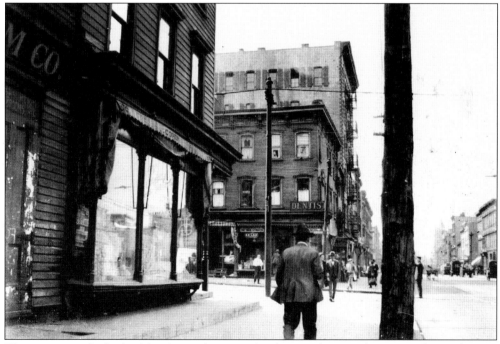

The caption on the back of this September 1923 Armbruster photograph states, "Chas. Debevoise owns the corner at left," presumably the frame building with the shop windows. A dentist's office occupied the three-story structure across the street. A policeman can be seen directing traffic at the intersection of Flushing and Bushwick Avenues, just to the right of the pole.

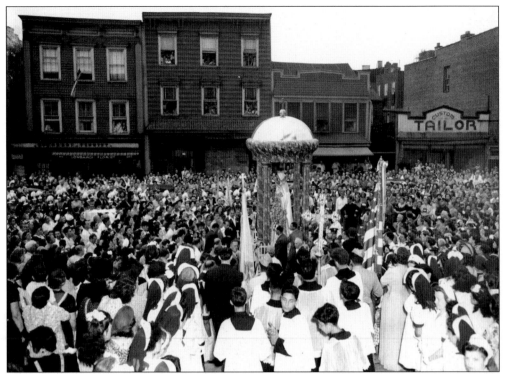

Locals, including a brigade of altar boys in the foreground, crowd Union Avenue c. 1950 for the Feast of St. Paulinus, a popular religious festival and street fair celebrated by the Italian American community of northeastern Williamsburg.

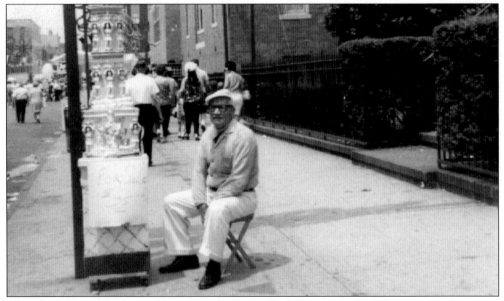

The object resembling a wedding cake in this mid-1960s image is a *giglio*, a tower decorated with religious images that is carried through the streets for celebrations of saints' days. The Italian community of northeastern Williamsburg has a tradition, now nearly a century old, of building *giglios* for such holidays.

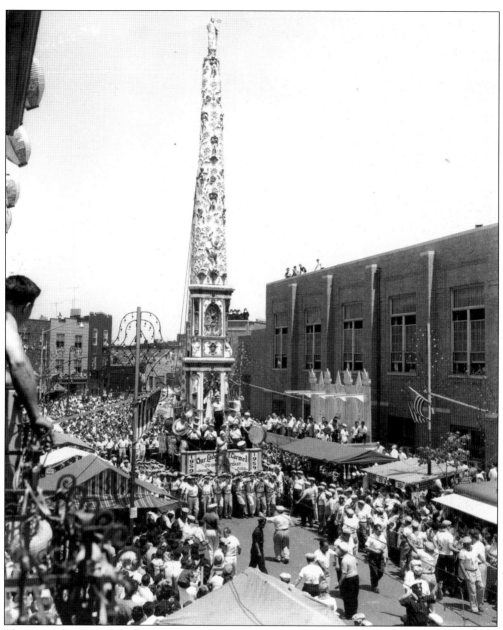

This enormous *giglio*, used in the 1959 procession celebrating the Feast of St. Paulinus, is typical for a major festival. The *giglio* is made of papier-mache over a wood or aluminum frame; several dozen strong men are needed to push, pull, and roll it on its course. The building at right is the Church of our Lady of Carmel on North Eighth Street, which sponsors the festival every summer.

Williamsburg

CHRIST CHURCH
Bedford Avenue
Near Division Avenue, Brooklyn

THREE SUNDAY EVENING
CONFERENCES ON LABOR
IN JANUARY, 1912

EVENING SERVICE, - - - - 7.45 p.m

Conference in the Chapel - - - 8.50 p.m
Division Avenue near Bedford

Jan. 14. Miss Josephine Eschenbrenner, of the National Child Labor Committee, will open the conferences upon "**Child Labor.**"

Jan. 21. Rev. Warren H. Wilson, Ph.D., Presbyterian Board of Home Mission, upon "**What Labor is Necessary on Sunday.**"

Jan. 28. Miss Frances Perkins, Secretary, Consumers League of New York, upon "**The Living Wage.**"

A hearty welcome is extended to all.

WM. SHEAFE CHASE, Rector.

REGINALD HEBER SCOTT, Curate

The Triangle Shirtwaist fire of March 23, 1911, was fresh in memory when this remarkable 1912 postcard was mailed, announcing three labor conferences sponsored by Christ Church on Bedford Avenue. The topics and discussion leaders are listed at right. Frances Perkins went on to a long and distinguished career in public service as Franklin D. Roosevelt's secretary of labor, the first American woman to hold a cabinet post.

Four

GIANTS OF INDUSTRY

By 1825, Williamsburg had developed into an affluent New York suburb, but everything changed after the opening of the Erie Canal that year. The canal served as the main artery of trade to the swiftly developing American interior, so manufacturers of consumer and industrial goods set up plants on the water, where costs were lowest to bring in raw materials and ship finished products in bulk on barges. Alert antebellum businessmen responded by building sugar and oil refineries, metalworks, chemical plants, and factories of every type and size on and near Williamsburg's East River shore.

The photographs that follow show these businesses in full operation, but the only survivor is Pfizer Pharmaceuticals, which continues to operate a sample packaging plant on Flushing Avenue. Schaefer Brewing, once a well-known name in the Northeast, closed its plant in 1976 and was sold in 1981. One of Williamsburg's oldest and largest facilities, the Domino Sugar refinery that once dominated the Southside riverfront closed in 2004; the area is slated for residential redevelopment. The Hecla Architectural Iron Works, one of the most important metalworkers in the history of the craft in the country, operated from 1897 to 1928 in a handsome building that still stands on North 11th Street.

The 255-acre New York Naval Shipyard, almost always called the Brooklyn Navy Yard, occupies Williamsburg's southwestern edge and is large enough to be considered a neighborhood of it its own. Its history includes the building of famous warships, including the Civil War ironclad *Monitor*; the USS *Maine*, whose sinking in a Havana harbor precipitated the Spanish-American War; and the USS *Arizona*, which sank at its moorings in Pearl Harbor in 1941. Closed as a shipyard in 1966, the yard now serves as an industrial park.

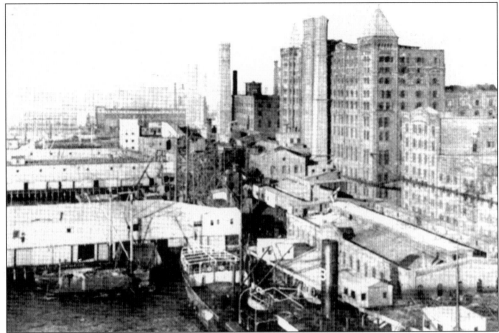

The bulky form of the American Sugar Refining Company plant along Kent Avenue in the Southside acts as a landmark in many Williamsburg images. The site was occupied by a sugar refinery from 1857, when Havemeyer, Townsend, and Company built a plant there, until 2004, when Domino Sugar, its corporate descendant, shut the factory. This *c.* 1910 *Brooklyn Eagle* postcard view shows the operation, including the pier, in full swing.

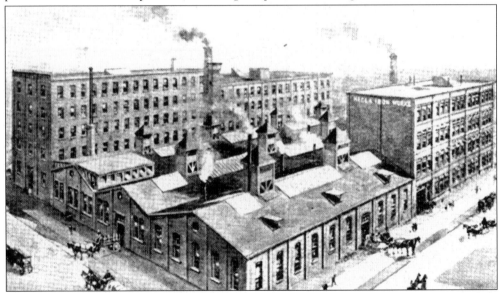

The Hecla Architectural Iron Works is shown in this *c.* 1910 postcard. Hecla designed and produced some of the finest ornamental metalwork in the country in the decades around the turn of the century, including the information booth in Grand Central Station and Prospect Park's Lullwater Bridge. The building at right carrying Hecla's name is now divided into residential lofts, shown in the photograph at the bottom of page 127.

F&M Schaefer Brewing was a Kent Avenue neighbor of the sugar refinery from 1915, when this photograph was taken, until 1976. Both used their river frontage to receive supplies and ship finished products. Note the large sign identifying the brewery building at left.

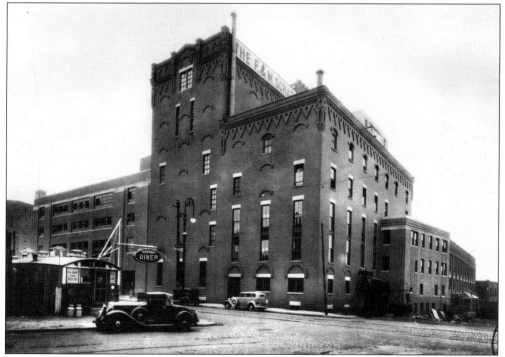

This image offers a clear view of the handsome old Schaefer brewery on Kent Avenue at South Ninth Street. The structure was expanded considerably before it closed in 1976, but even this building dwarfed the Garden Diner, across the street at the lower left. This photograph is undated, but the automobiles suggest that it was taken in the mid-1930s.

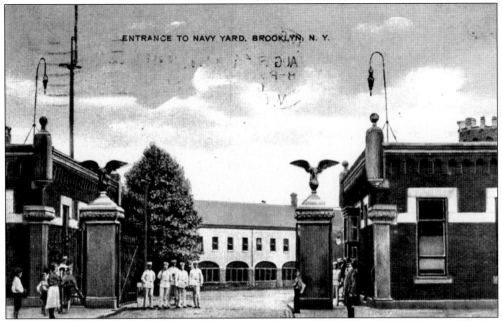

ENTRANCE TO NAVY YARD, BROOKLYN, N. Y.

Military pride is the theme of this *c.* 1909 postcard image of the Brooklyn Navy Yard's main gate. The navy yard was founded in the first decade of the 19th century. Brooklyn's largest employer by far during World War II, it is a city-owned industrial park today.

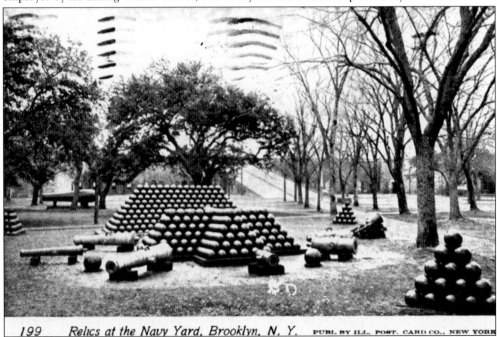

199 Relics at the Navy Yard, Brooklyn, N. Y. PUBL. BY ILL. POST. CARD CO., NEW YORK

The Brooklyn Navy Yard faces Wallabout Bay, a small cove that during the Revolutionary War was a harbor for British prison ships on which thousands of Americans died under harsh conditions. The old cannons and cannonballs are likely what the caption calls "relics" from that time. More touching than the relics is the handwritten message: "I am happy that my little girl is recovering from her attack of tonsillitis. Father."

62

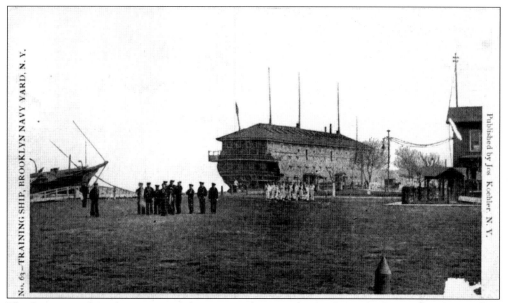

No. 64—TRAINING SHIP, BROOKLYN NAVY YARD, N. Y.

Published by Jos. Koehler, N. Y.

The boxy vessel at the center of this postcard image dating from the beginning of the 20th century is described as a training ship. Note the more graceful prow of a sailing ship to the left.

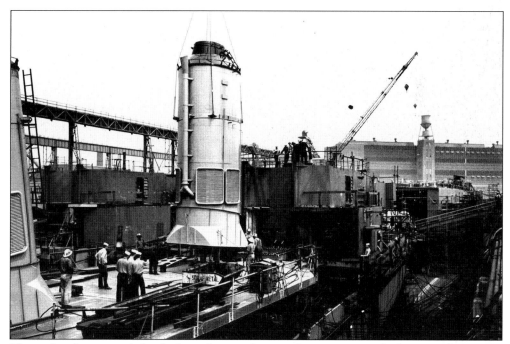

The scale of navy yard dry-dock work is evident in this image, in which a vessel's massive smokestack is lifted easily from its place. Barrett Gallagher took this photograph on May 18, 1962, just four years before the navy closed the yard.

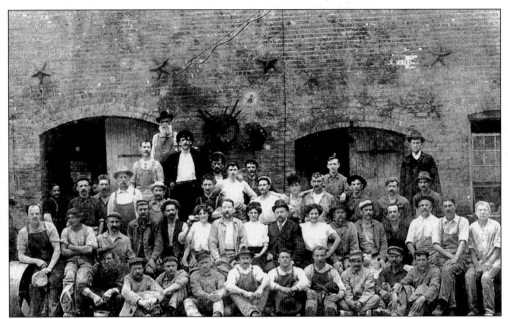

The firm that grew into Pfizer Pharmaceuticals was founded in Williamsburg by two German immigrants in 1849. Starting as a manufacturer of fine chemicals, Pfizer moved gradually into the pharmaceuticals business during the 1920s and 1930s. Pfizer still operates a plant in Williamsburg today. This wonderful c. 1900 image shows employees assembled in front of the tinsmith shop off Flushing Avenue. (Courtesy of Pfizer.)

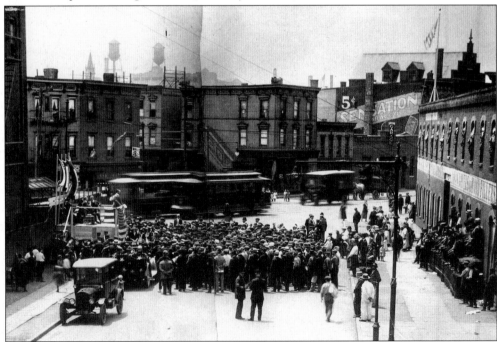

An orator urges Pfizer employees and passers-by to buy war bonds at a World War I–era rally outside the plant. Note the trolley and other traffic along a busy Flushing Avenue in the background. (Courtesy of Pfizer.)

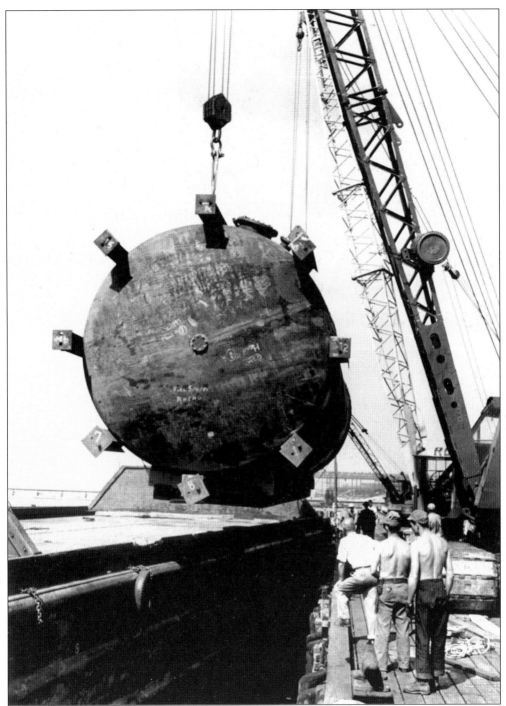

Since many of its early products were fermented, Pfizer developed considerable expertise in the process, which later put the firm in a strong position to manufacture the antibiotic penicillin. The storage tank shown in this remarkable hot-weather photograph from 1936 contained molasses used in fermentation. Here it is to be lowered into the East River to cool the sugar. (Courtesy of Pfizer.)

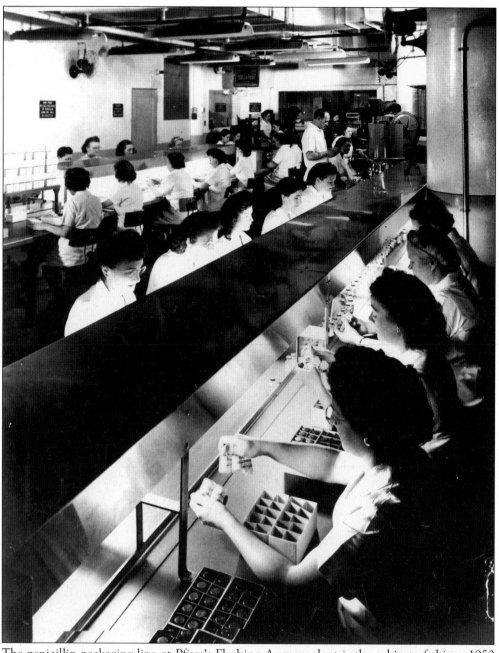

The penicillin packaging line at Pfizer's Flushing Avenue plant is the subject of this *c.* 1950 photograph. Interestingly, packagers of the day worked barehanded. (Courtesy of Pfizer.)

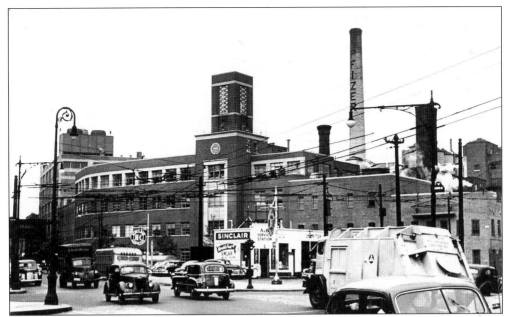

Pfizer had an enormous presence in the South Williamsburg neighborhood, as shown in this c. 1950 view of its administration building at Flushing Avenue and Bartlett Street. The squarish building at left was part of the plant. Note also the smokestack bearing the Pfizer name. Today, the administration building is a New York public school. (Courtesy of Pfizer.)

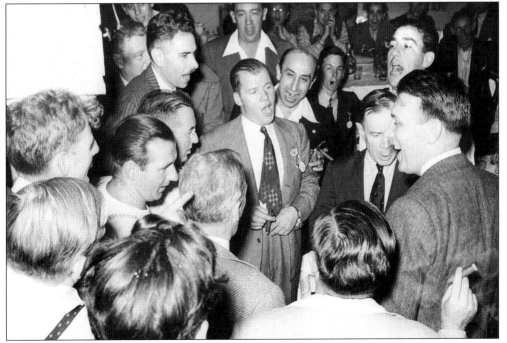

Brooklyn native John McKeen joined Pfizer in 1926 as a process engineer. He rose through the firm to become superintendent of the Flushing Avenue operation, then chairman of the board from 1950 to 1968. McKeen, seen in the center, clearly possessed the charisma required of a leader, as evidenced in this image of him singing at a 1942 company party. (Courtesy of Pfizer.)

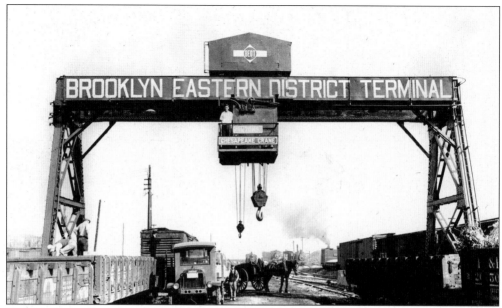

Williamsburg, Greenpoint, and several other parts of northwestern Brooklyn were once grouped together under the administrative rubric Eastern District. The Eastern District Terminal was a transportation center combining rail, pier, and warehouse facilities on the East River from North Third to North Tenth Streets. This c. 1920 image shows a horse and wagon, automotive trucks, and rail cars under the crane.

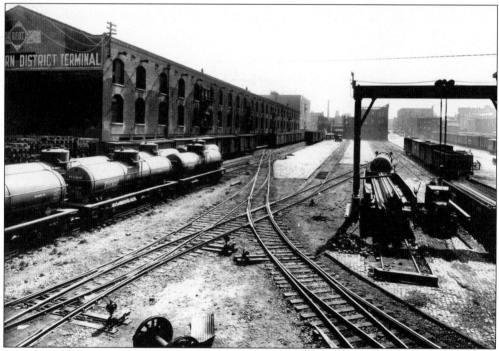

W. R. Harrison created an interesting photographic study from the linear patterns of the Eastern District Terminal's tracks. The terminal, a 1906 venture of the Erie Railroad, operated until 1983. This image dates from c. 1930.

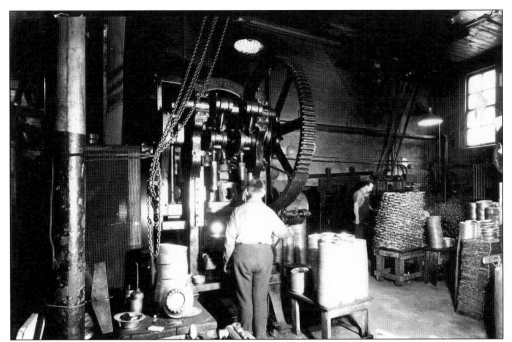

A. Kreamer manufactured tin-plate goods at Kent Avenue and South Third Street. Here, men work at the Kreamer plant c. 1915. The man at center, with his back to the camera, feeds plates from the piles at his right into a press; the finished product is stacked to his left, with one plate carefully propped on display.

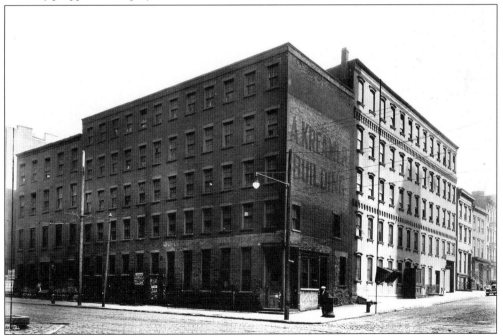

The dark building at center was A. Kreamer's factory; note the "A. Kreamer Building" sign on the South Third Street side. The structure shown in the c. 1915 photograph has since been demolished.

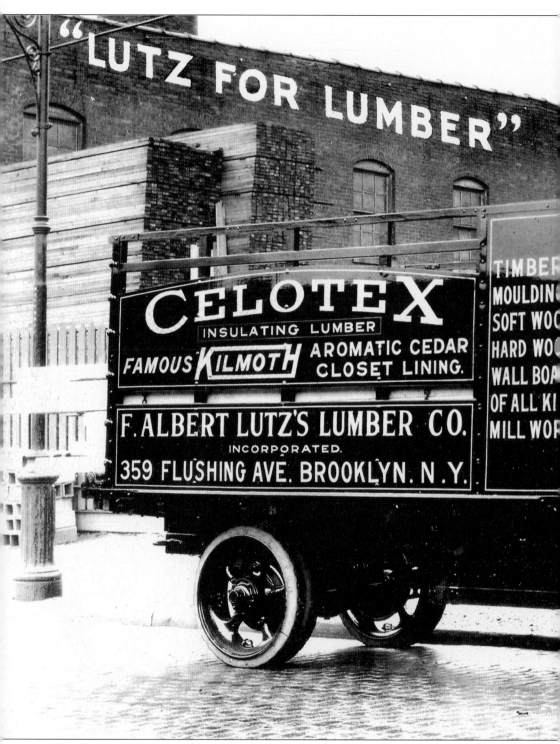

"LUTZ FOR LUMBER"

CELOTEX
INSULATING LUMBER
FAMOUS *KILMOTH* AROMATIC CEDAR
CLOSET LINING.

F. ALBERT LUTZ'S LUMBER CO.
INCORPORATED.
359 FLUSHING AVE. BROOKLYN. N.Y.

TIMBER
MOULDIN
SOFT WOO
HARD WO
WALL BOA
OF ALL KI
MILL WOR

This great *c.* 1920 image of Lutz's Flushing Avenue lumberyard captures an era of growth and optimism. The crisply lettered and sparkling delivery truck, the bold warehouse signs, and the meticulously stacked wood in the yard match the fastidious style of the man in the foreground,

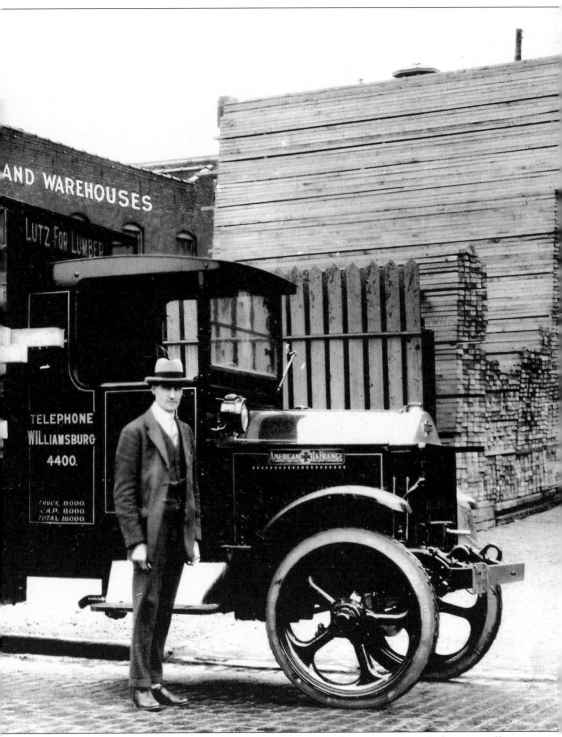

likely F. Albert Lutz. The list of products painted on the truck is interesting; Celotex is still a familiar name in the industry.

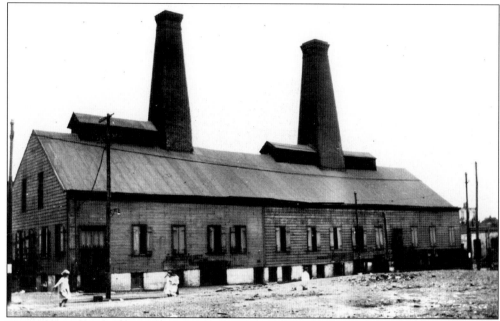

The Williamsburgh Flint Glass Company was a corporate ancestor of Corning Glass. The tapering chimneys of its McKibben Street plant, shown in this 1922 Armbruster photograph, must have been an important East Williamsburg landmark. Note the very young children playing in the adjoining yard.

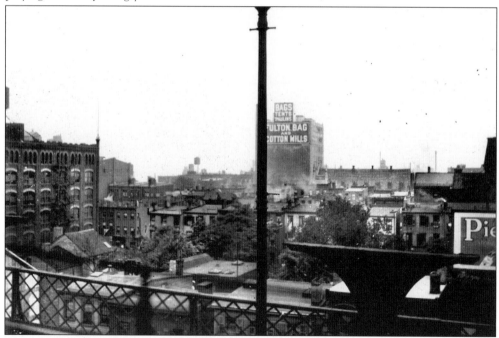

The Fulton Bag and Cotton Mills building on South Fifth Street, near Wythe Avenue, is visible just to the right of, and partially obscured by, the lamppost at center. Armbruster took the photograph in 1922 while facing south from a roof on South Second Street. The Atlanta-based Fulton Bag was a major cotton weaver in the early 20th century.

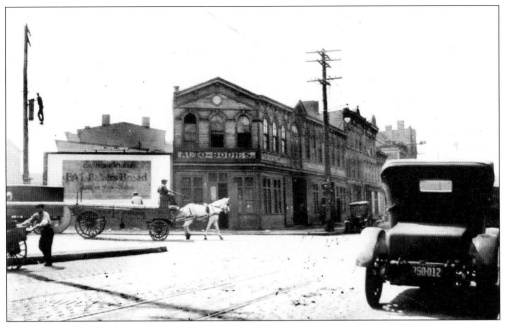

The caption on the back of this *c.* 1923 Armbruster image identifies the "former Brooklyn Blade plant s.e. cor. Flushing Ave. & Beaver St.," by then an auto body shop at the border of Williamsburg and Bushwick. Note the vendor pushing his cart at left, the man working on the power line directly above him, and the horse-drawn wagon at center.

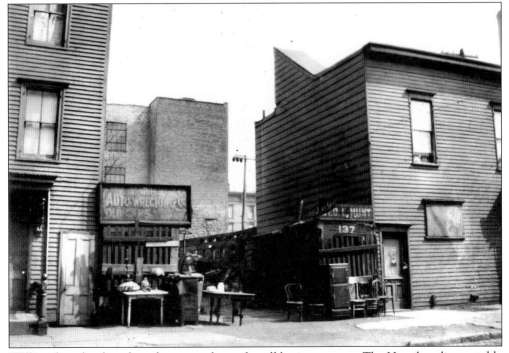

Williamsburg has long been home to a host of small businesses, too. The Hamilton livery stable and George I. Hunt, auto wrecker and dealer in old furniture and china, shared a yard on North Fourth Street off Bedford Avenue, seen in this 1929 urban study by Armbruster.

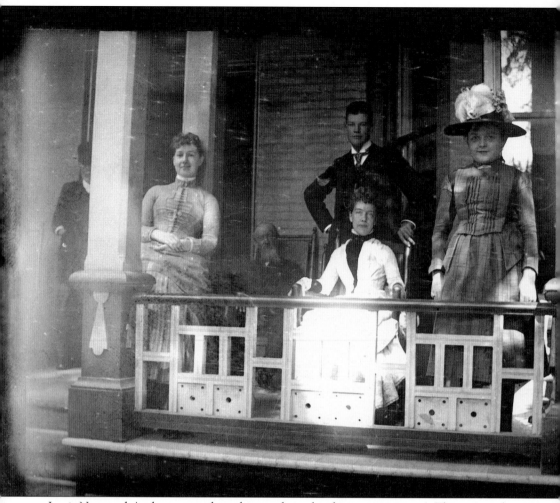

Louis Nostrand Anderson stands on his porch in this fine group portrait. The woman leaning against the column at left (also shown on page 77 sitting in a chair) was likely his wife. Note the older, bearded man in the rocking chair and the spectacular hat worn by the young woman to the right.

Five
FACES OF WILLIAMSBURG

The photographs that follow capture Williamsburg residents of long ago at work and play in images of immediacy and great beauty. In the 1880s series showing the Nostrand family on the porch of their Taylor Street home, for example, we see members of an old clan with a famous Brooklyn name relaxing in a setting that looks suburban. No less remarkable are the images taken of teamster and saloon keeper Charles Schindler among family and employees at his home and businesses on Devoe Street *c.* 1910. The people in these photographs have obviously been posed but look at the camera in a relaxed and friendly manner, making the near century of elapsed time seem insignificant.

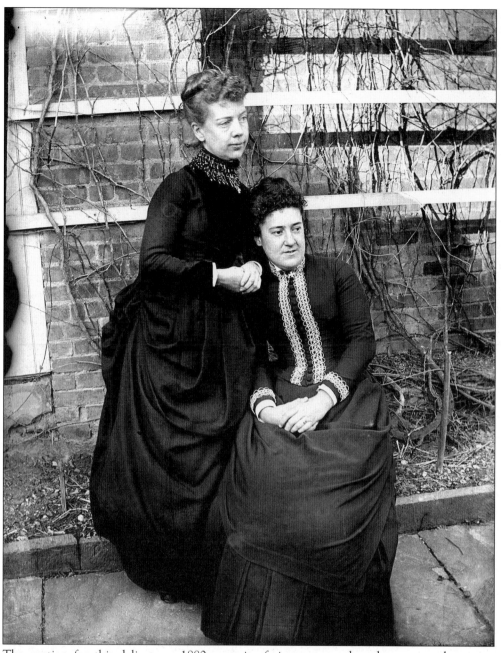

The caption for this delicate c. 1880 portrait of sisters states that the women shown are "Mother [left] and Aunt Minnie (Nostrand) of L. N. Anderson at 149 Taylor Street."

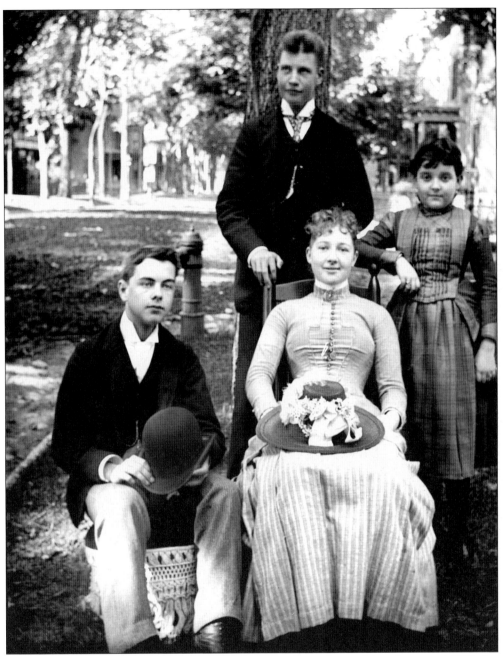

Members of the Anderson family take ease on a sunny day in front of their home at 149 Taylor Street. Louis Nostrand Anderson, descended on his mother's side from Brooklyn's ancient Nostrand family, stands at center. Today, Taylor Street is the site of a housing project deep in Williamsburg's Hasidic area; it could hardly contrast more strongly with the leafiness of this glass-negative image from the 1880s.

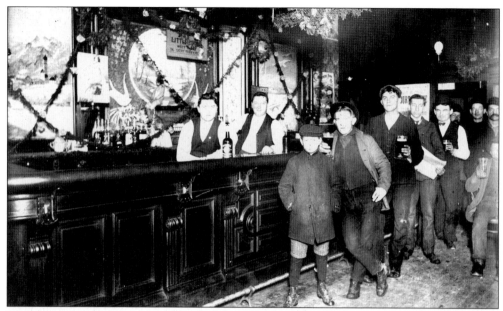

This group was photographed inside the bar of Charles Schindler, a Devoe Street saloon keeper and trucker, *c.* 1905. The caption on the reverse states that Schindler's brother-in-law John Heins, standing behind the bar with the open vest, "was a boxer. . . . In World War I he was a member of Squadron 'C' stationed at Brooks Field, Texas. He taught boxing to pilots as a means of self-defense should they be forced down in enemy territory."

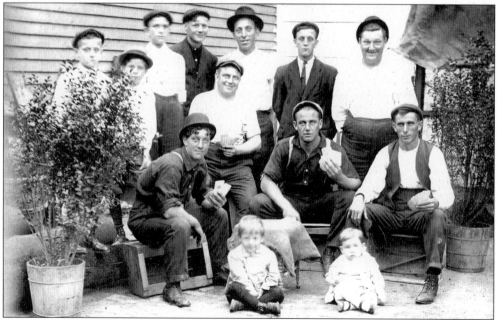

Employees of Schindler's Trucking Company play cards in this *c.* 1910 group portrait by the Commercial Photographic Company. The caption identifies "the rotund gentleman" standing at the right of the back row as Charles Schindler, then relates the following: "Schindler never had a motorized vehicle in his company. He believed that motorized trucks would never replace those pulled by horses. When the horse went out of trucking, Uncle Charlie went out of business."

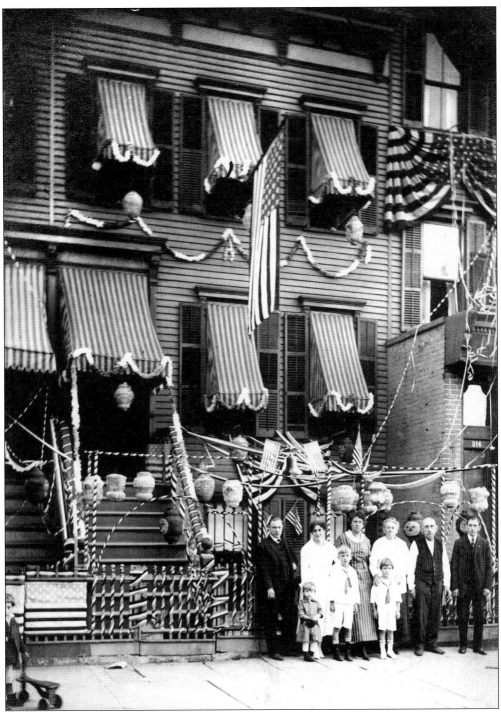

The exterior of Charles Schindler's attractive Devoe Street home is elaborately decorated for this photograph. Although the exact date and occasion are not known, the demonstration of patriotism suggests the World War I years; the warm-weather garments make Memorial Day or the Fourth of July the likeliest holidays.

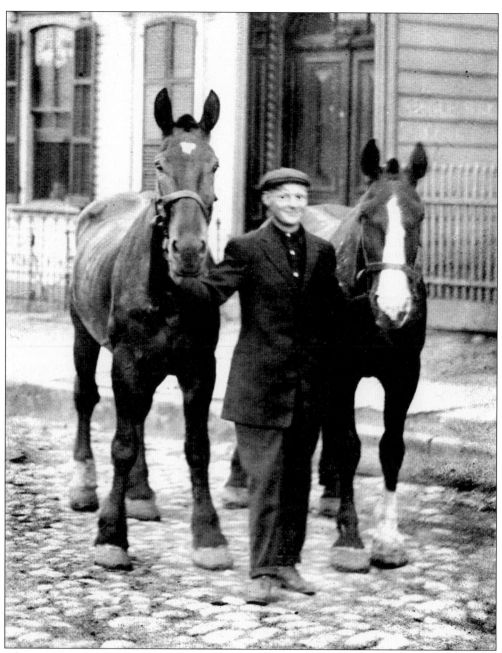

Johnny White, a driver at Schindler's Trucking Company on Devoe Street, appears in this *c.* 1910 memento of the horse-drawn-truck era. Although obviously confident at handling horses, White is shy in front of the camera. The caption on the back of this image indicates that it was shot by "Commercial Photographic Co., Photographers and Publishers, Brooklyn, N.Y. Chas. Davies, Manager."

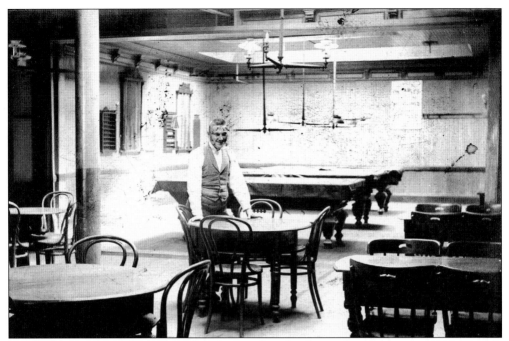

An older but still jovial Charles Schindler stands in his Devoe Street saloon *c.* 1915. Though Schindler may have lacked a keen sense of the future of trucking, he also sold the ever popular elements of a bar: beer, billiards, and companionship.

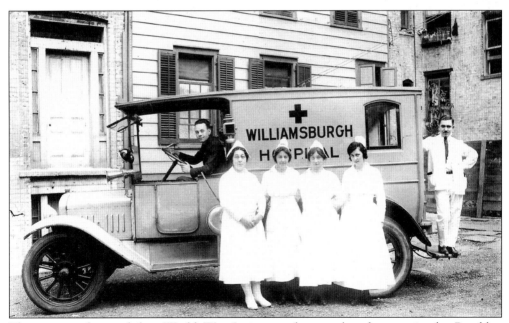

This is one of several fine World War I vintage photographs of nurses in the Brooklyn Historical Society's archive. These nurses worked at the Williamsburgh Hospital on Bedford Avenue and South Third Street, also shown in the image on page 48. The caption on the back of this 1918 photograph identifies the third nurse from the left as Elvira Hoffman.

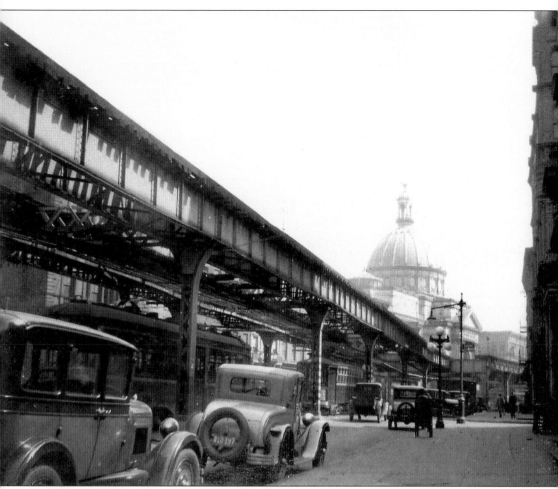

In March 1929, Eugene Armbruster photographed the Broadway scene from the opposite side of the tracks from the cover image, the tracks being those of the 19th-century elevated line that brought Brooklyn residents to the Grand Street ferry terminal. Taken near the southwest corner of Broadway and Bedford Avenue, this view shows the dome of the Williamsburgh Savings Bank, as well as a glimpse of the great cast-iron buildings on Broadway at right.

Six

ARCHITECTURAL TREASURES PAST AND PRESENT

Williamsburg has long enjoyed the presence of public and private structures of extraordinary interest, as the images in this chapter show. Some of the buildings in the photographs that follow are gone, but many still stand, especially on and off Broadway, making that street the logical starting point for architectural sightseeing.

Most of the grandest buildings date from the second half of the 19th century, when Williamsburg was a booming industrial, commercial, and residential district. Perhaps the most wonderful of these is the old Kings County Savings Bank, at the northeast corner of Bedford Avenue, a mansard-roofed, Beaux-Arts masterpiece in superb condition that is today the home of the Williamsburg Art and Historical Center. Just down the street to the east stand the eye-catching dome of the Williamsburgh Savings Bank and, around the corner on Williamsburg Bridge Plaza, the Williamsburg Trust Company—the former one of New York's finest classical revival buildings, the latter now the Holy Trinity Orthodox Church. Nearby are several magnificent cast-iron structures.

Broadway, old Williamsburg's main street, boasts the greatest concentration of landmark buildings, but explorations of other parts of the neighborhood will reward the interested visitor. Even streets without designated landmarks possess a richness and variety that can only be found in an older part of town, where structures of mixed size, use, and age stand side by side.

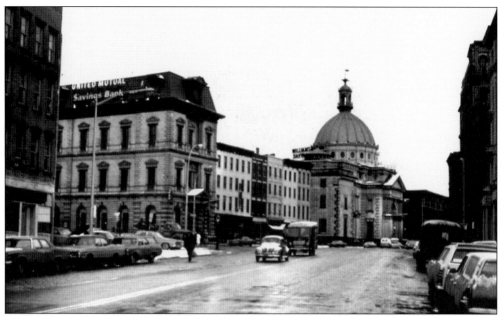

The buildings of downtown Broadway are shown to great advantage without the tracks of the el blocking the view. The street displays all its grandeur in this c. 1974 photograph, taken looking east from Wythe Avenue, with the old Kings County Savings Bank left of center, and the stately dome of the Williamsburgh Savings Bank down the street.

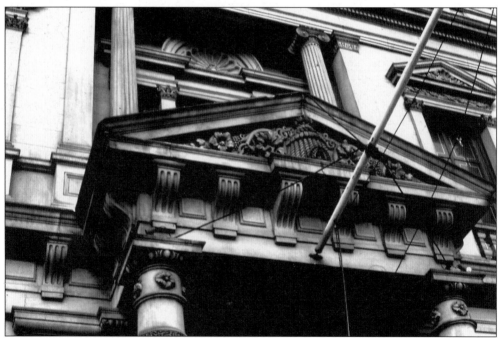

The magnificent sculptural detail on the pediment above the door to the Kings County Savings Bank is the subject of this study, taken around the same time as the previous image. Note the woven-reed dwelling in the center, a tribute to the area's long vanished Native American residents.

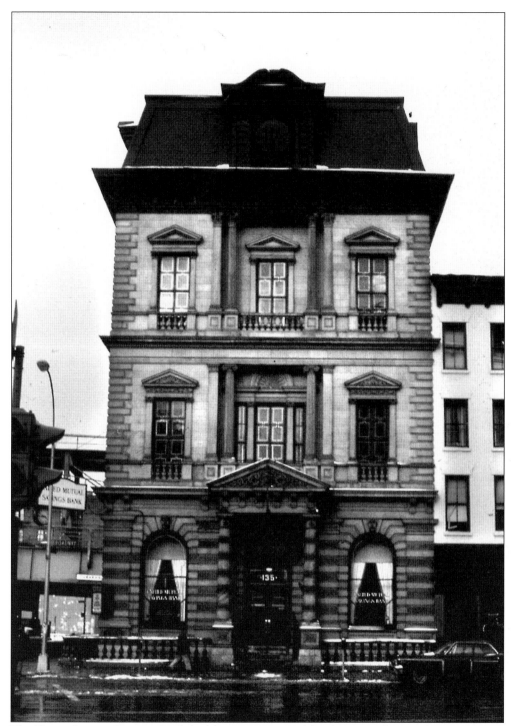

The Kings County Savings Bank building was occupied by the United Mutual Savings Bank in the mid-1970s, when this admirably clear view was taken from across Broadway. Rich in character, the structure was designed by William H. Wilcox. It serves today as the Williamsburg Art and Historical Center.

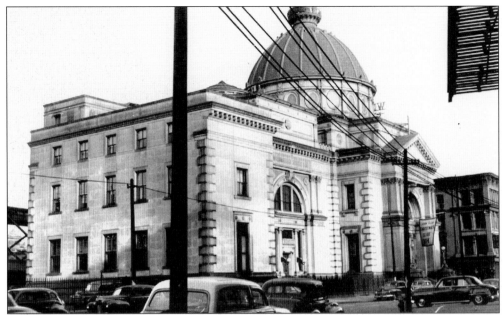

The Williamsburgh Savings Bank building at 175 Broadway, completed in 1875 and later added to and restored, is the work of architect George B. Post. One of the most important figures in New York architectural history, Post also designed the New York Stock Exchange building in Manhattan and the Brooklyn Historical Society's headquarters on Pierrepont Street in Brooklyn Heights.

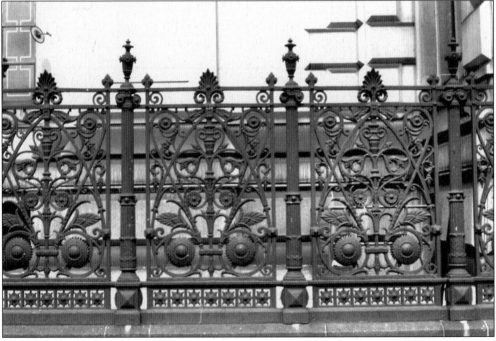

The Williamsburgh Savings Bank is one of New York's greatest buildings in the classical style, with a powerful presence and rich detail. This 1970s image shows the magnificent cast-iron fence that surrounds it.

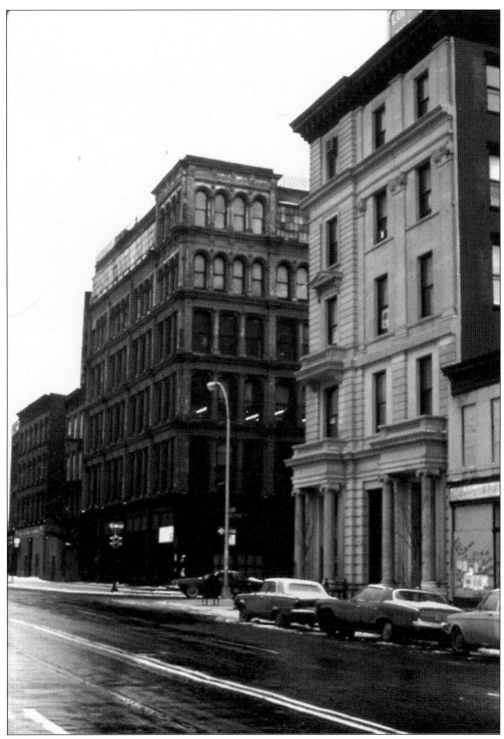

The south side of Broadway does not lack great buildings, either, as this mid-1970s view of the intersection at Bedford Avenue shows. The fine stone structure at right was built in 1888 as the Nassau Trust Company; a superb *c.* 1870 cast-iron building stands across Bedford.

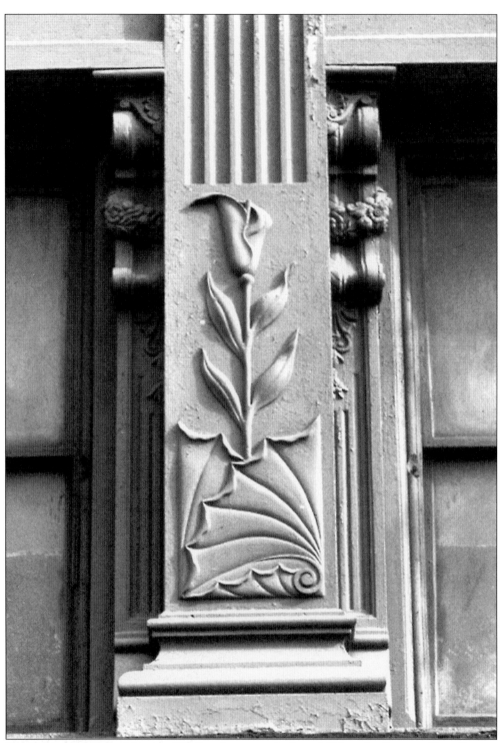

The Forman family building, at 195 Broadway, was built in 1882 as the Sparrow Shoe Factory Warehouse. This 1975 study by Becket Logan, of a decorative detail from one of the pilasters on the façade, demonstrates how cast iron combines delicacy with strength.

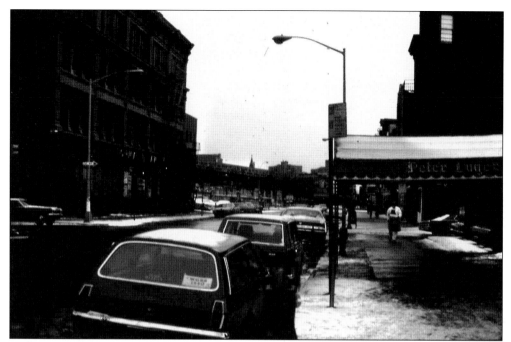

Williamsburg's beloved culinary landmark, Peter Luger's Steakhouse, is shown at right in this *c.* 1974 view east along Broadway toward Driggs Avenue. Founded in 1876 as Charles Luger's Café, Billiards, and Bowling Alley, the restaurant has for more than 50 years been under the stewardship of the Forman family, which also owns the fine cast-iron building across Broadway at the left.

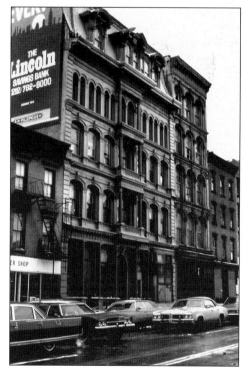

These two magnificent cast-iron buildings at 99 and 103 Broadway stood on the north side of the street, between Berry Street and Bedford Avenue. The structure at 99 Broadway has since been torn down, and an apartment house is under construction on the site. The beautiful 103 Broadway still stands. Even though this *c.* 1974 image shows the buildings before Williamsburg turned fashionable, the richness of the Broadway streetscape is unmistakable.

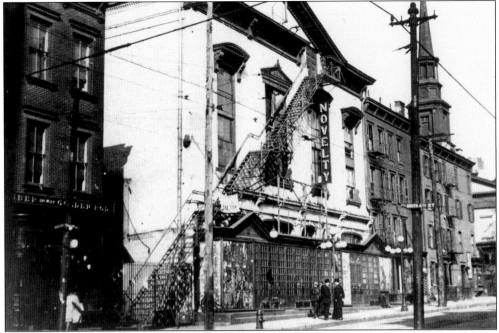

An attractive mid-19th-century architectural hybrid of Greek Revival form and Italianate detail, the Odeon Theatre stood on Driggs Avenue between South Fourth and Fifth Streets. By 1915, approximately when this photograph was taken, it had been renamed the Novelty. The spire of the South Third Street Presbyterian Church, shown on pages 100 and 101, can also be seen at right.

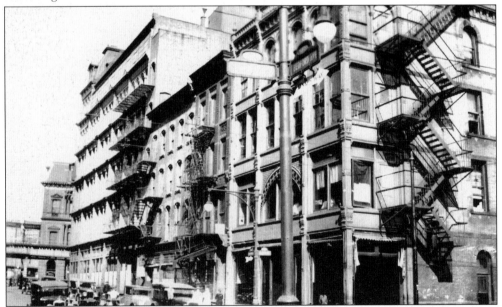

This 1928 Armbruster photograph shows a cast-iron building that is no more. Behind the lamppost on Bedford Avenue and South Eighth Street stands the Smith Building, erected in the 1860s as a department store. Notable for its grand arched entryway, it was demolished in the late 1990s and replaced by a bland brick apartment house.

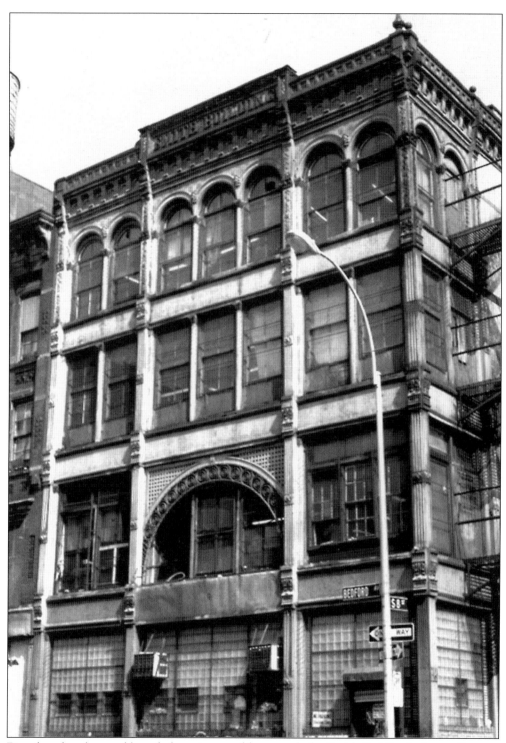

Decades of neglect and brutal alterations could not mask the Smith Building's elegant lines, as this 1977 view by Esther Mipaas shows. Note the remnant of the archway in the second floor and the building's name in the cast-iron cornice of the central section.

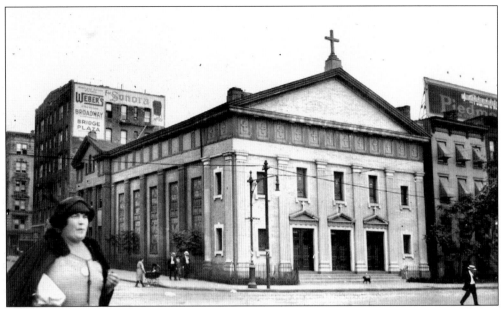

This Greek Revival temple, built in 1848 as the First Presbyterian Church, still stands at the northeast corner of South Fourth and Roebling Streets. It served Williamsburg's large Polish Catholic community as St. Mary's Queen of Angels when Armbruster took this photograph in 1922. Today, it is the headquarters of Los Sures (Spanish for "the Southsiders"), a local Hispanic organization.

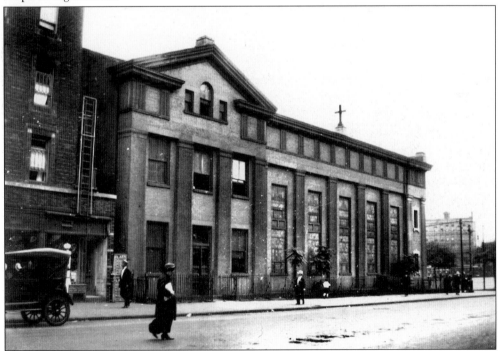

The west side of St. Mary's Church is revealed in this 1922 Armbruster view from Roebling Street. The section under the pediment appears to be the chapel; the open space looming at right is the Williamsburg Bridge Plaza.

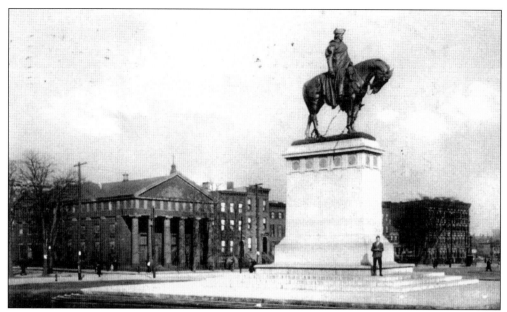

The north side of the Williamsburg Bridge Plaza, St. Mary's Church, and Henry M. Shrady's equestrian statue of Washington form a tranquil urban space in this 1908 postcard view. Today, crowded with entrances to the bridge, connections to the Brooklyn-Queens Expressway, and the elevated subway tracks running from the bridge onto Broadway, the plaza is anything but peaceful.

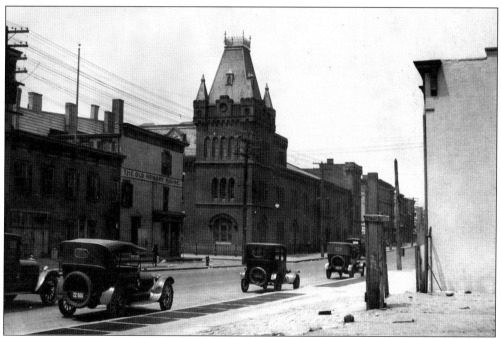

The 32nd Regiment Armory, built to resemble a French chateau, stood at Bushwick Avenue and Stagg Street. The Old Armory House, the saloon across the street, left of center, "was kept by an old couple who lost their son in the Brooklyn Theatre Fire," according to the caption on the back of this 1922 Armbruster view.

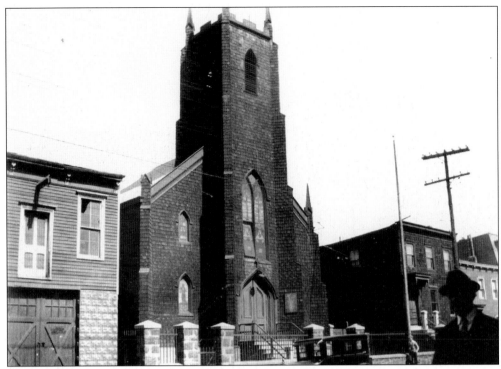

Williamsburg's houses of worship are amply documented in the Brooklyn Historical Society's photographic archive. This 1928 study by Armbruster shows the shingled Grace Protestant Episcopal Church, located on the north side of Conselyea Street between Lorimer and Leonard Streets. Note the stable, with its hayloft and hoist, at left. Although the church is gone, this remains an exceptionally beautiful block.

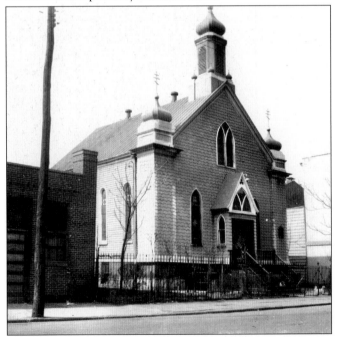

The caption on the back of Armbruster's 1929 photograph states that this building was the "former St. Michael's Church now a Greek Cath church . . . north 5th Streets ab. 75 feet west of Driggs Av." The onion domes, characteristic of the Eastern Orthodox Church, tell the story of its transformation.

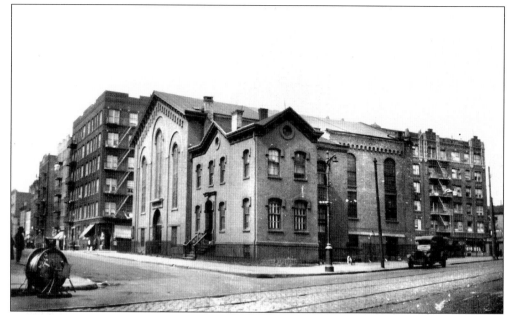

Armbruster effectively juxtaposed the styles of two architectural eras in this image from March 1929. The somber mid-19th-century forms of the South Third Street Methodist Episcopal Church and parsonage are framed by the massive bulk of a block of apartment houses that could not have been more than 10 years old when the photograph was taken. The church stood on the north side of the block, between Hooper and Hewes Streets.

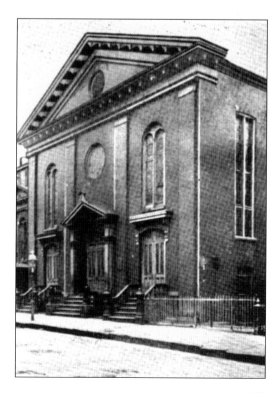

The South Second Street Methodist Episcopal Church is the subject of this *Brooklyn Daily Eagle* postcard, issued *c.* 1910.

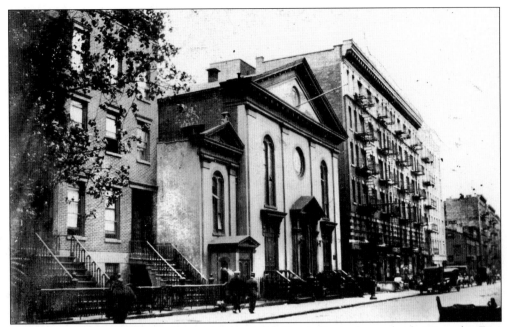

Armbruster's clear 1922 view shows the beautiful Greek Revival temple that was the First Methodist Episcopal Church of Williamsburg, on South Second Street between Driggs Avenue and Roebling Street. The church remains, serving today as the Christian Pentecostal Church of God. The tenement buildings to its right have been demolished.

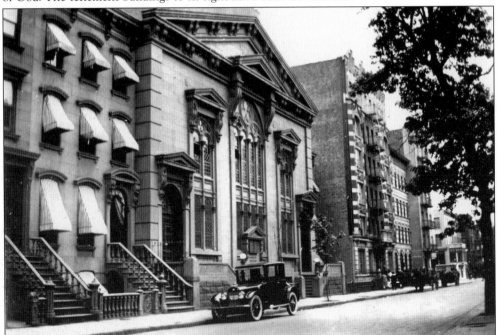

The New England Congregational Church, seen in this 1922 Armbruster view, is one of Williamsburg's most beautiful architectural treasures. Completed in 1853 and renovated after a fire in 1894, the Italianate structure of brownstone, wood, and glass still stands on South Ninth Street, between Driggs Avenue and Roebling Street, as the Light of the World Church.

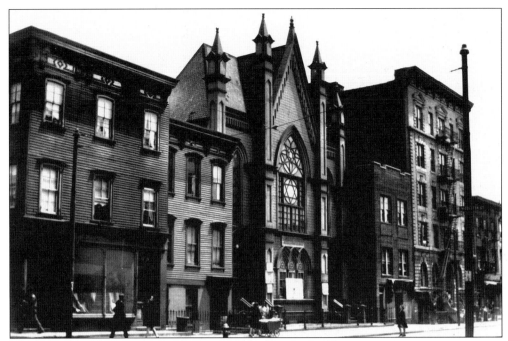

The caption for this *c*. 1925 image states only that the building at center is a synagogue on Middleton Street near Harrison Avenue. Note the fine frame houses to its left. The synagogue, in what is now the heart of Williamsburg's Hasidic district, no longer exists.

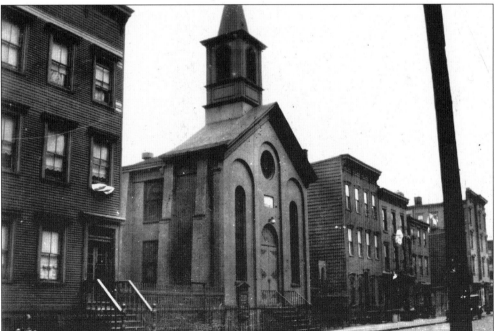

Armbruster took this view of St. Matthew's German Evangelical Lutheran Church, located on North Fifth Street between Roebling Street and Driggs Avenue, in March 1929. The handsome 1864 structure, one of Williamsburg's survivors, today serves as the Iglesia Bautista Calvario (Calvary Baptist Church). A contemporary image is on page 128.

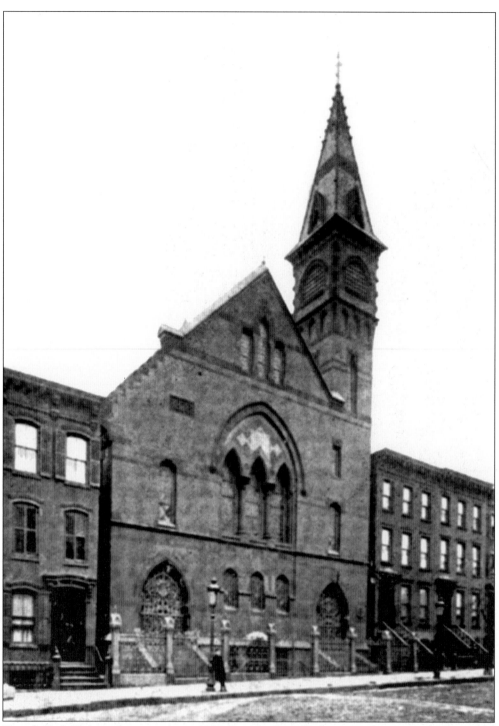

Temple Beth Elohim, shown in this *c.* 1910 *Brooklyn Daily Eagle* postcard view, was built in 1876 to serve one of the area's earliest German Jewish congregations. The church-like Gothic structure, which is today a Hasidic synagogue, stands on Keap Street near Division Avenue in South Williamsburg. Although the peak of the tower has been removed, the building is still beautiful.

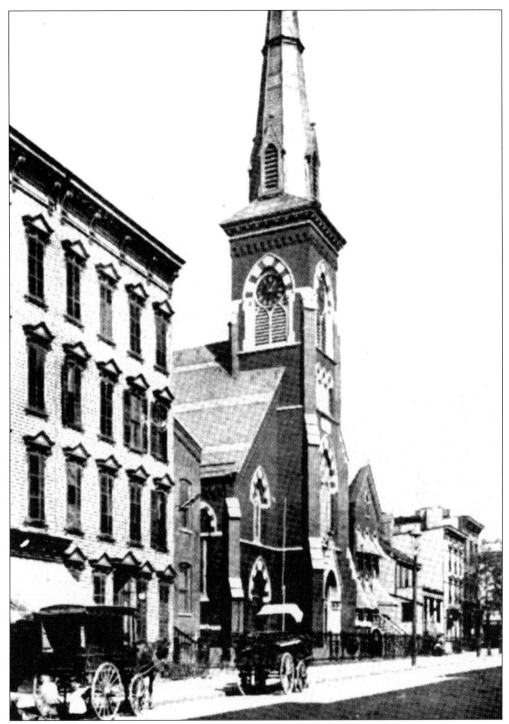

St. John's Evangelical Lutheran Church on Maujer Street in East Williamsburg is the subject of this c. 1910 *Brooklyn Daily Eagle* postcard. Williamsburg's Lutheran churches served the area's German population, which was enormous in the mid- and late 19th century and the early 20th century. This lovely structure remains today.

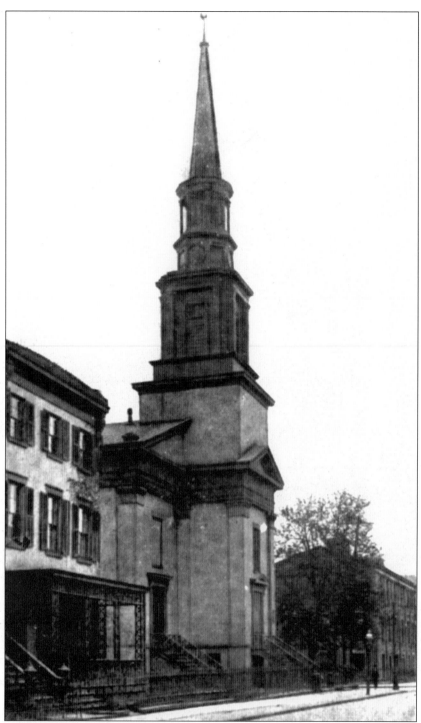

The busy, gritty intersection of South Third Street and Driggs Avenue bears little resemblance today to the tranquil street of this c. 1910 postcard image. The main difference is that the handsome South Third Street Presbyterian Church is now gone, the well-tended homes and trees along with it.

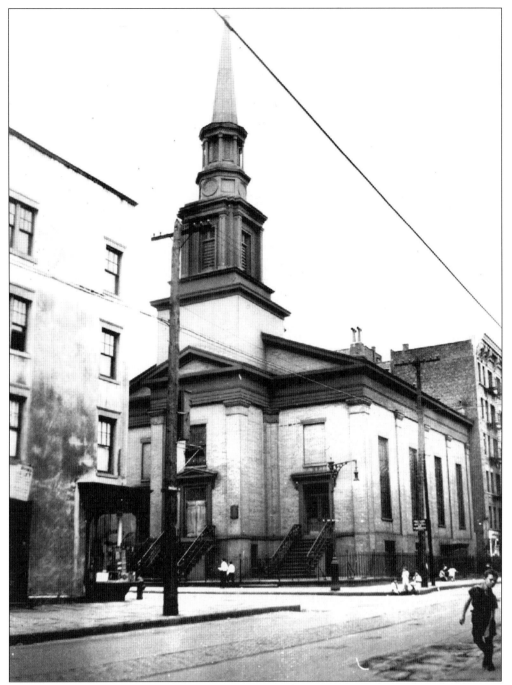

Twelve years made a palpable difference to South Third Street and Driggs Avenue, as this 1922 Armbruster image shows. The streets are crowded with children, and although the Presbyterian church's sober Greek Revival form still holds its dignity, the building appears run-down and hemmed in by the apartment houses surrounding it.

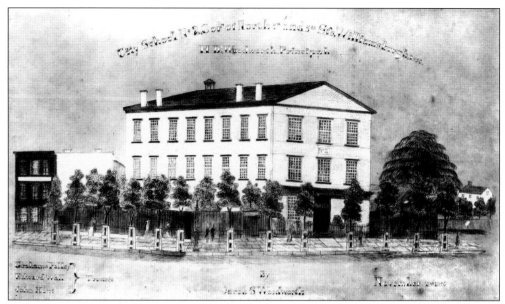

Although the captions for this image and the one below provide conflicting information about the location of school shown, the building is clearly the same in both. This 1858 print calls it the North Fifth Street School, and informs us that Henry Dudley Woodworth served as its principal. The surrounding area looks suburban.

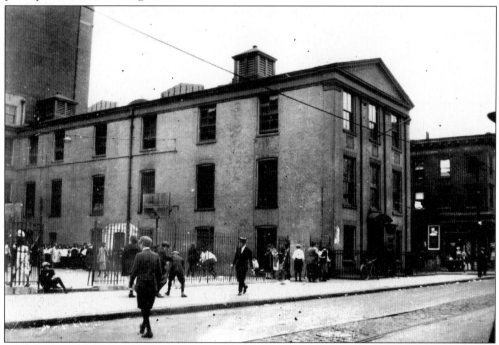

The 1843 schoolhouse had grown shabby by the time Armbruster photographed it in 1922, and Williamsburg had urbanized completely in the intervening decades. The caption on the back gives the school's location as South Third Street and Fifth, the old name for Driggs Avenue. This is the correct location, as the structure can be seen clearly in the view looking down South Third at the top of page 106.

Images of Williamsburg's public schools from the early 20th century show buildings modest in scale but exuberant in style. This 1931 photograph of PS 37, a spectacular Victorian-era building that stood on South Fourth Street near Berry, is but one example of the fine old schoolhouses that were once common in Williamsburg.

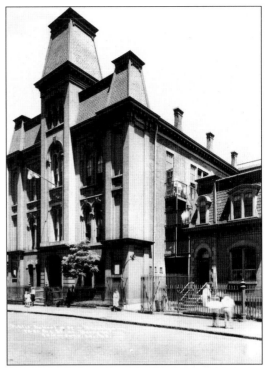

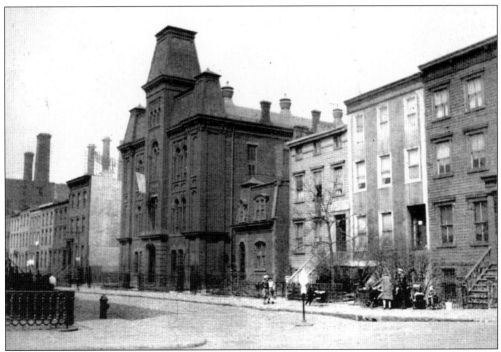

In March 1929, Armbruster took this image of PS 37 from a wide angle on South Fourth Street, showing the full visual impact of the ornate building against its older, more architecturally conservative neighbors. The smokestacks to the left in the background belonged to the American Sugar refinery on Kent Avenue.

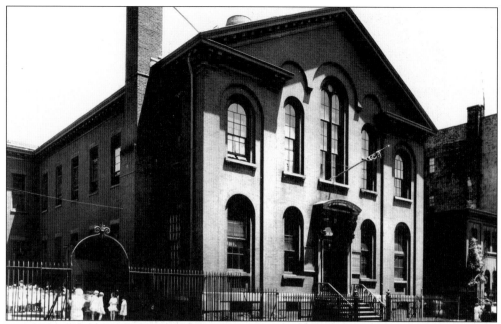

Most old schools erected before buildings had electricity were designed to allow in as much daylight and fresh air as possible. This *c.* 1930 view of PS 38, on North Seventh Street near Berry, displays the building's big windows and side yards for enhanced ventilation. The caption on the back reads, "Official photograph Board of Education City of New York."

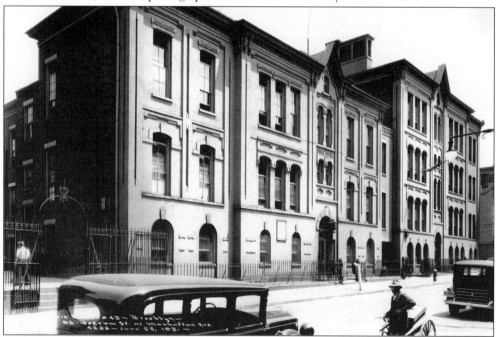

Another official board of education photograph, this 1931 image shows PS 43, at Boerum Street and Manhattan Avenue in East Williamsburg. Note the yard at left, the large windows, and the distinguished Italianate design of the building, which probably dated to the 1870s. The man with the wagon at lower right appears to be an ice-cream vendor.

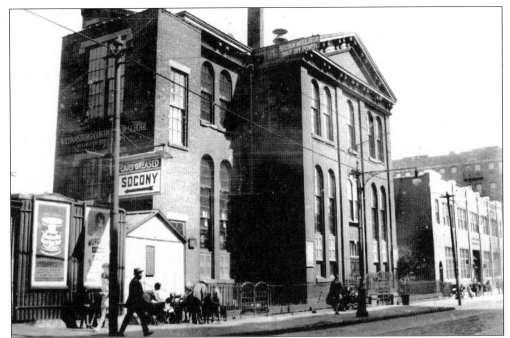

The Williamsburg Continuation School occupied the handsome Victorian structure at South Fourth and Havemeyer Streets shown in this *c.* 1920 Armbruster image. The institution provided vocational courses for youngsters who had to leave primary and secondary school to work, surely a common situation at a time when the neighborhood was still absorbing armies of poor immigrant families. Today, the Brooklyn-Queens Expressway runs where the school once stood.

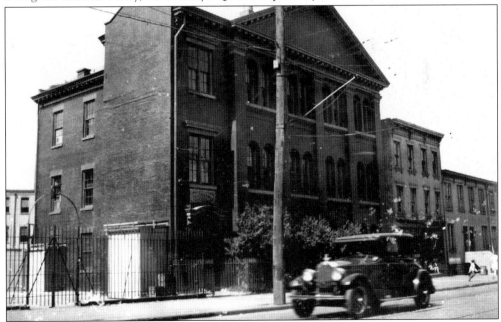

This view of PS 20, which stood on Union Avenue at Devoe Street, shows clearly how small the building was. Built in 1869 in the Italianate style, the schoolhouse was ornamented with a large, but not disproportionate, triangular pediment. Armbruster photographed it in September 1928.

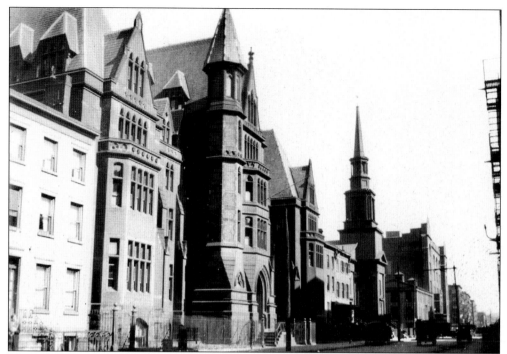

The grand Gothic building at center was the Industrial School Association, which was likely a trade school. Armbruster photographed the building, located on South Third Street between Bedford and Driggs Avenues, in October 1928. The school's spires are echoed by that of the Third Street Presbyterian Church, just right of center. The church is also shown on pages 100 and 101.

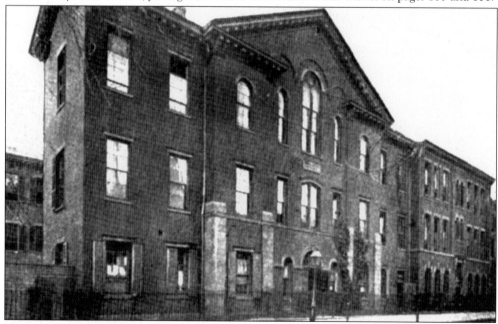

PS 16, the subject of this *c. 1900 Brooklyn Eagle* postcard, bore a strong resemblance to PS 17, shown on page 107. A much larger PS 16 has since replaced the old school on Wilson Street near Bedford Avenue.

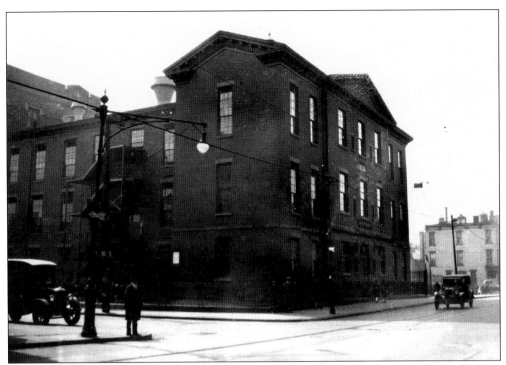

The caption on the reverse of this 1928 photograph, presumably written by Eugene Armbruster, describes this schoolhouse as the "old building of PS #17 former District School #2 of Williamsburgh on the northeast corner of Driggs Avenue & North 5th Street. The oldest part is the portion fronting on North 5th Street." Armbruster's note is uncharacteristically long, suggesting that he knew the building well.

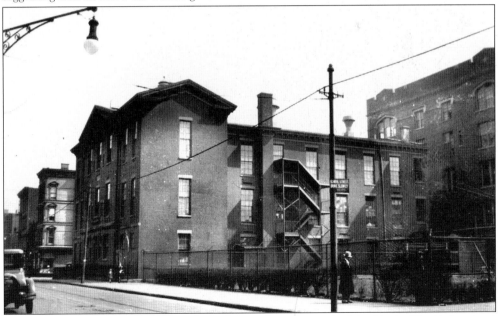

Armbruster took this second view of PS 17 from the other end of the block. The little school is dwarfed by its replacement, seen here at right, the PS 17 that stands today.

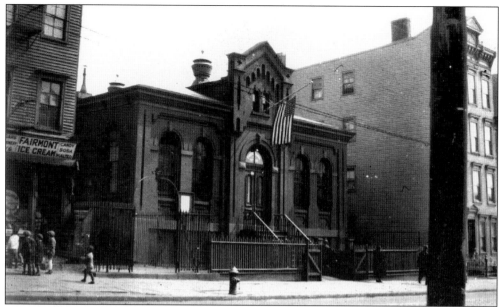

A remarkable survivor among Williamsburg's old public schools is Colored School No. 3, completed in 1881. The dainty Romanesque-style structure, photographed by Armbruster in 1929, still stands on Union Avenue between Scholes and Stagg Streets. The school was given landmark status in 1998. Note the crowd of boys in front of the candy store in the building at left.

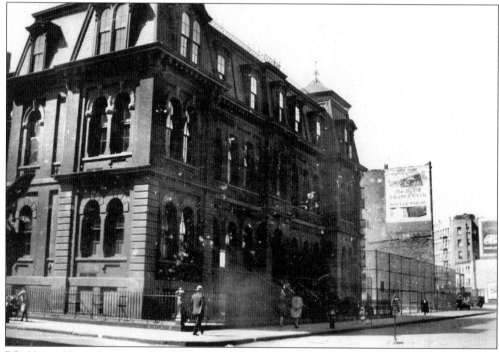

PS 19, at Keap Street and Wythe Avenue, was another splendid Beaux-Arts confection. Although not centered, Armbruster's 1928 photograph does give a good view of the schoolyard at right.

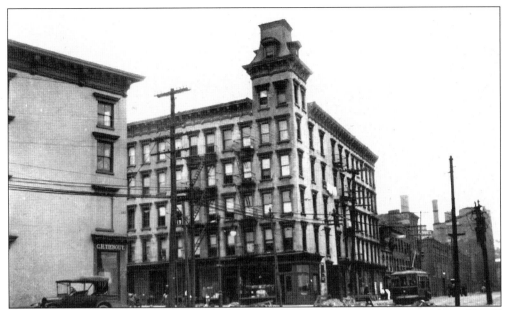

The caption on the reverse of Armbruster's 1922 view of the "former Metropolitan Hotel" states that the building stood on the "southeast cor First & Grand St.," First Street being the old name for Kent Avenue. The hotel, which opened in 1871, was a relic of Williamsburg's boom years in the late 19th century, when its waterfront was a major commercial center. Note the trolley running on Kent Avenue at right.

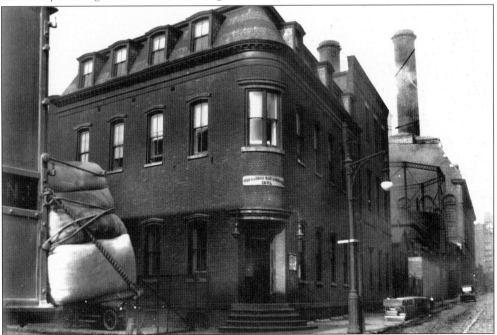

The interesting rounded structure shown in this mid-1920s Armbruster image was the office of the Nassau Gas Light Company. The caption indicates that structure ("built 1874?") stood on the corner of Cross Street and Kent Avenue, near Clymer Street. Neither the building nor Cross Street exists today. On the left is the end of a delivery truck with canvas sacks tied to its gate.

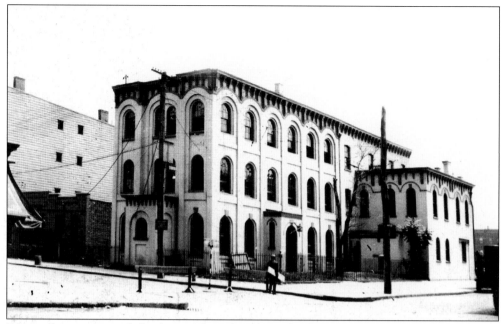

Even police stations of the late 19th and early 20th centuries had charm, as revealed in Armbruster's 1922 study of the Sixth Precinct headquarters on Bushwick Avenue and Stagg Street. The caption notes that the land on which the station house was built had been "owned in 1855 by Chas. Schenck." The Schencks were an old Brooklyn family.

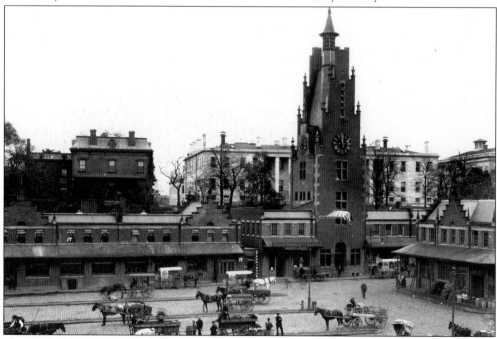

The Wallabout Market (also shown on page 52) was housed in idealized versions of buildings one might find in a Dutch town square. This late-19th-century view shows the market with a great landmark of the Brooklyn Navy Yard in the background—the Naval Hospital of 1838, which is partially blocked by the clock tower.

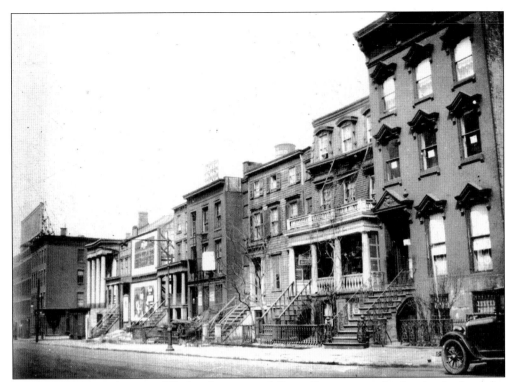

South Fifth Street between Wythe Avenue and Berry Street was a fascinating hodgepodge of building materials and architectural styles when this view was taken in March 1929. A photograph of the house at the far end of the block appears below. Two large industrial buildings occupy the block today.

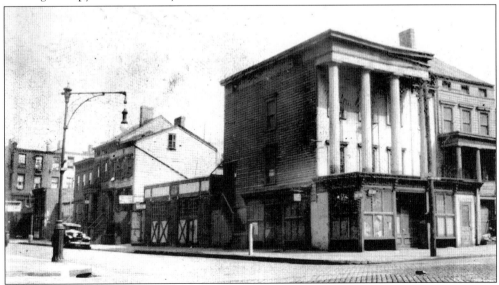

The two-story portico and columns on the front of this small frame house hint at pretensions to grandeur by the builder or original owner. The ground-floor storefront looks like a later addition. This odd structure, which stood at the northeast corner of South Fifth Street and Wythe Avenue, was photographed by Armbruster in 1929.

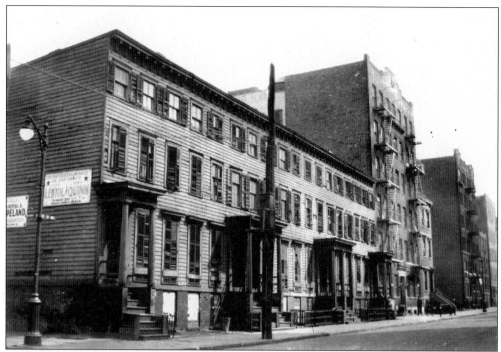

Although these frame houses, built during the heyday of the Greek Revival, were showing their age when Armbruster photographed them in March 1929, the elegant purity of their lines remained unmistakable. The houses, which stood on the northeast corner of South Third and Berry Streets, attest to Williamsburg's mid-19th-century prosperity.

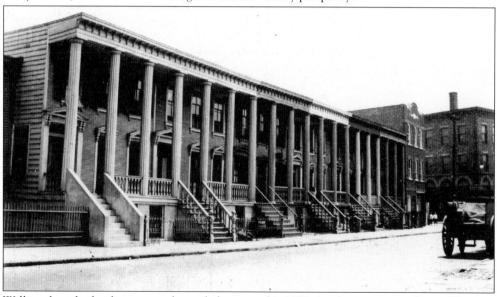

Williamsburg had at least one colonnaded row, as this 1922 Armbruster image shows. This one stood on Humboldt Street, between Herbert and Richardson Streets. Its architectural relatives include LaGrange Terrace on Lafayette Street in Manhattan, and the colonnaded houses on Willow Place in Brooklyn Heights. Two houses of this handsome row have survived, although considerably altered.

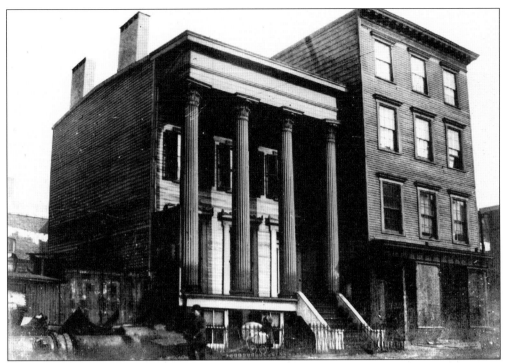

This fine house, in high Greek Revival style, stood at 44 South Tenth Street, just off Wythe Avenue. The structure was small but well proportioned. Armbruster photographed this remnant of Williamsburg's prosperous past in 1923.

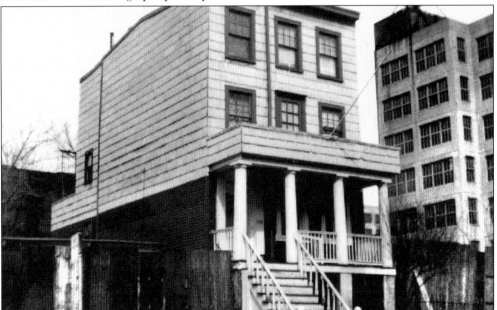

John D. Morrell's 1958 photograph of the house at 69 South Fifth Street, between Berry Street and Wythe Avenue, captures another, even more drastic attempt to make a humble home look impressive. The effect of the Doric portico on the plain structure is somewhat comical but not unpleasing.

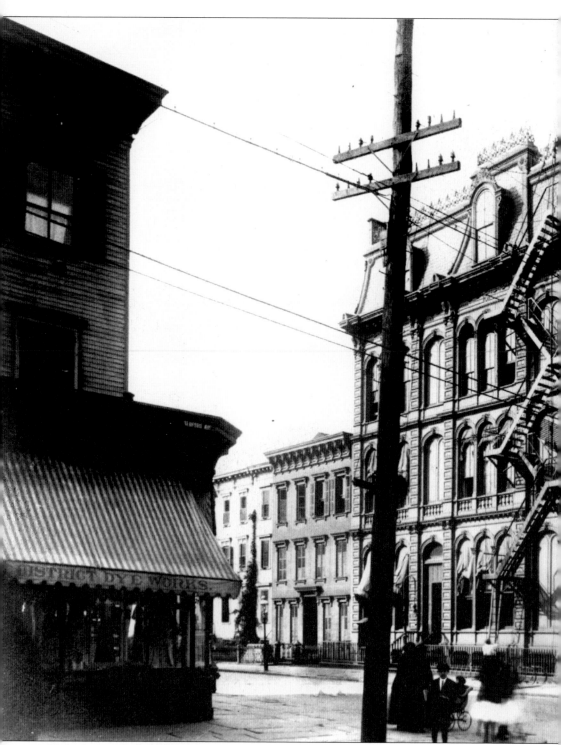

Had it survived, the magnificent Beaux-Arts office of the Brooklyn Union Gas Company, built in the mid-1860s and demolished in 1967, would have taken its place among Williamsburg's great architectural treasures. This view of the building, which stood at the corner of Bedford

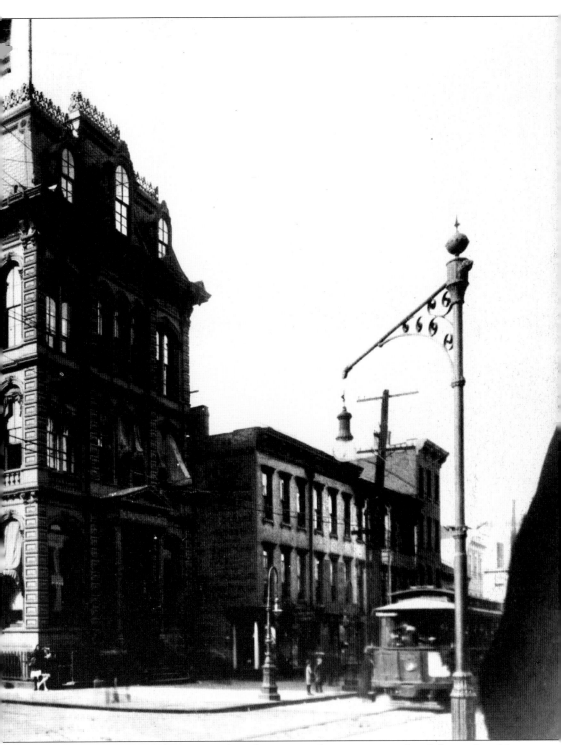

Avenue and South Second Street, with pedestrians and a streetcar, is dated September 15, 1913. This is the same intersection as the one in the image on page 36.

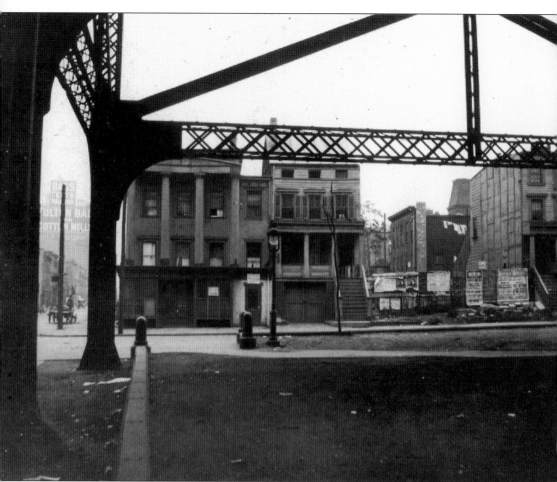

The last vestiges of Williamsburg's gentility had mostly disappeared by the late 1920s, when Eugene Armbruster took this powerful image of devastation: the once elegant homes of South Fifth Street at Wythe Avenue crumbling in the shadow of the Williamsburg Bridge. These are the same houses shown on page 111.

Seven

DEVASTATION AND RENEWAL

Williamsburg's waterfront and Southside (west from Union Avenue, between South First Street and Division Avenue) suffered worst from the job losses and poverty caused by the factory closings in the decades after World War II. Parts of East Williamsburg were also burdened by drug addiction, crime, and hundreds of abandoned buildings. Housing projects sprouted around the middle of the 20th century, draining the life from the surrounding streets. In the darkest days of the 1970s, doubters of New York's survival pointed to Williamsburg's pockets of devastation as unfixable urban wastelands. The problems of the waterfront remain difficult, as a drive along Kent Avenue will show. This potentially beautiful riverside street, with its extraordinary Manhattan views, is notable chiefly for vast, garbage-strewn lots interspersed with small industrial businesses.

Yet the Southside, along with the Northside (the "north" numbered streets) and, less famously, East Williamsburg, have rebounded remarkably in the last 25 years. As crime was effectively reduced in New York during the booming 1980s and 1990s, the matchless energy and excitement of the city proved irresistible to young people. Many willingly renounced the suburbs for borderline lower Manhattan neighborhoods like the East Village, Chelsea, and the Lower East Side. Others chose Williamsburg, just across the East River. They followed artists, who have always been first to find cheap studio space in neighborhoods where some fear to go. The tide also turned in East Williamsburg, where immigrants from South and Central America and the Caribbean joined an established Puerto Rican community to form a vibrant Hispanic district.

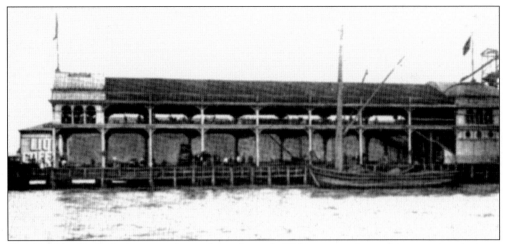

This *Brooklyn Daily Eagle* postcard view from the early 20th century shows the recreational pier at North Second Street on the East River. Although many miles of New York waterfronts were industrialized, they were nonetheless cherished by New Yorkers in the days before air-conditioning.

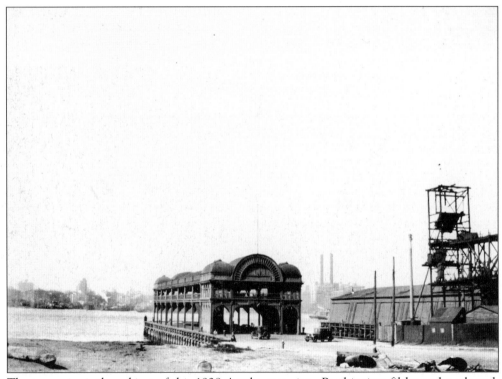

The same pier is the subject of this 1928 Armbruster view. By this time filthy and neglected, the Williamsburg waterfront appears to have been abandoned for any recreational use. Even though the Northside has become fashionable, most of Williamsburg's East River frontage remains a wasteland.

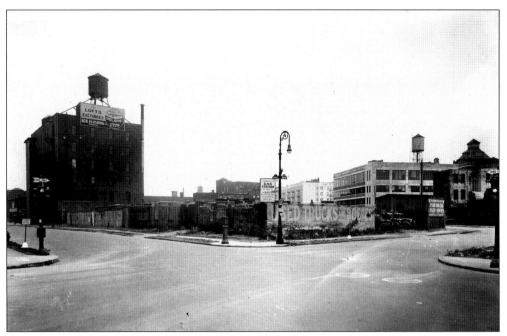

Large swaths of Williamsburg had become desolate industrial landscapes by 1940, when a Royal Photo Studio photographer took this view of the intersection of Kent Avenue and Rutledge Street. The purpose of this bleak image is not certain, but the inscription on the back, "Block 2223," suggests it may have been taken for the city or an insurance company.

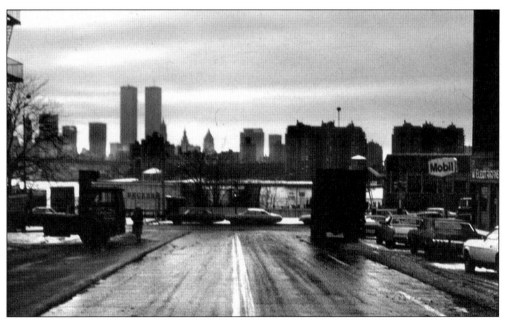

The Manhattan skyline, dominated by the towers of the World Trade Center, rises grandly in this mid-1970s winter view of the western end of Broadway. A large catering hall was recently built here on the west side of Kent Avenue, a remarkable change for this once heavily industrialized area.

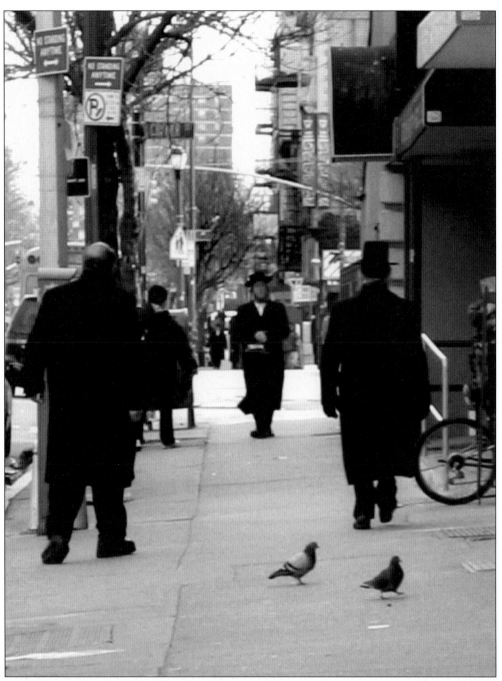

Lee Avenue in South Williamsburg is today one of the main shopping streets in the area's huge Hasidic district. Ultraorthodox Hasidic Jews, whose grooming and dress follow biblical instructions as well as eastern European traditions, scrupulously observe even the smallest law given in the Torah. Most of Williamsburg's Hasidim (plural for the Hebrew word *hasid*, meaning "pious person") belong to the Satmar sect, named for the town in northwestern Romania where the group originated.

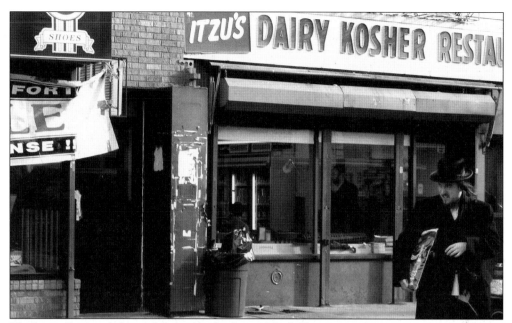

The laws of *kashrut* (what makes food kosher) are of the highest importance to observant Jews. One of the fundaments of *kashrut* is that meat and dairy products may never be cooked or eaten together, explaining the sign on this Lee Avenue restaurant, where no dishes containing meat are prepared.

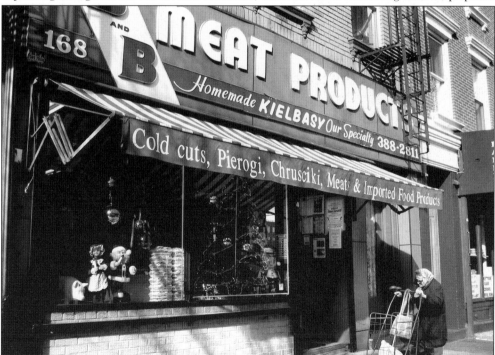

Thousands of Polish Americans live in Williamsburg's Northside, the numbered streets above Grand Street and west roughly from Union Avenue to the East River. The Northside also borders on Greenpoint, which has an even larger proportion of Polish residents. This Bedford Avenue butcher shop offers old-world delicacies to the community.

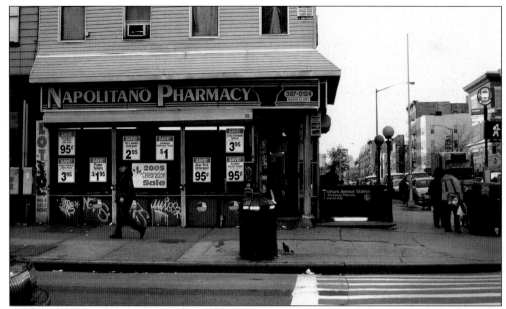

This view of an old neighborhood drugstore at the corner of Metropolitan and Graham Avenues shows the subway station, just right of center, for the "L" train, one of Williamsburg's major axes of public transportation. The Brooklyn tower of the Williamsburg Bridge is visible just above the entrance to the subway, and there is a faint glimpse of the Manhattan skyline in the distance.

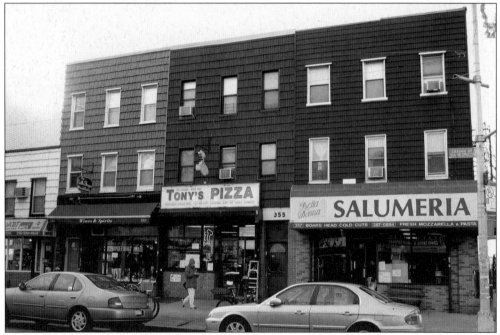

With its epicenter on Manhattan and Metropolitan Avenues, northeastern Williamsburg is home to a large Italian American community. This contemporary view was taken one block away, at Graham Avenue and Conselyea Street. Although clean, safe, and filled with good restaurants and cafés, this part of Williamsburg receives relatively few outsiders as visitors.

Graham Avenue is the main street of East Williamsburg's large Hispanic community. Pioneered in the middle of the last century by Puerto Ricans, the area is now home to a diverse group of immigrants from Mexico, the Dominican Republic, and other nations in Central and South America. This contemporary photograph shows a clothing shop on Graham Avenue, between Moore and Seigel Streets.

Nothing is more astonishing to New Yorkers accustomed to thinking of Williamsburg as a slum than its transformation into a hip community. Centered near the "L" train stop at Bedford Avenue and North Seventh Street, the Northside has become a desirable address, with rents to match. This recent view of Bedford Avenue and North Sixth Street shows a coffeehouse and a Japanese restaurant—neither to be found in the area until recently.

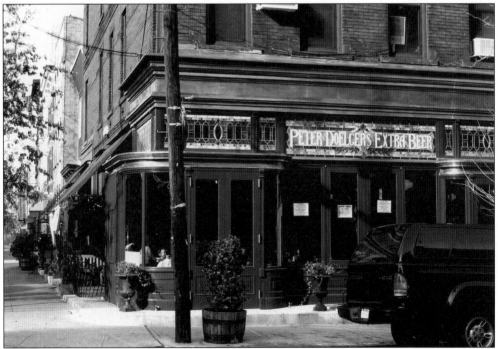

This popular bar and restaurant on North Eighth and Berry Streets has witnessed Williamsburg's rise, fall, and rebirth. The handsome stained-glass sign in its window advertises the product of a long-vanished local brewery.

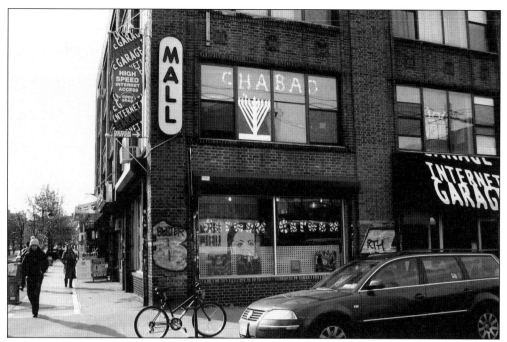

A former industrial building on Bedford Avenue at North Fifth Street has been converted into a small, unconventional indoor mall with stores selling fashionable clothing, books, coffee, wine, cheese, music, and Internet access.

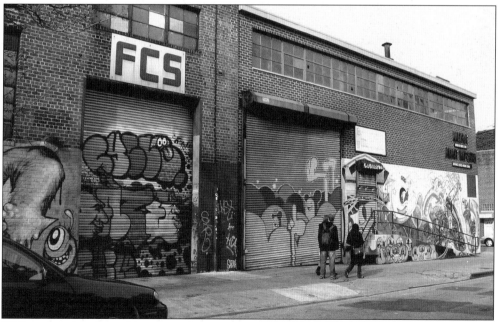

Williamsburg's industrial businesses have not completely disappeared, as shown in this scene of contemporary Bedford Avenue. The building at left is occupied by a steel fabricator; an importer and a framer share the one to the right. All, however, have accommodated the area's fashionable status by allowing the graffiti of talented local artists to decorate their buildings.

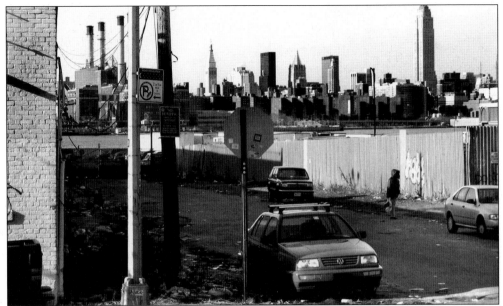

Kent Avenue, Williamsburg's westernmost street, has not experienced the renaissance enjoyed by much of the neighborhood. The area consists chiefly of vast properties that were once occupied by heavy industry. The value of spectacular Kent Avenue waterfront sites like those shown here is likely to rise dramatically.

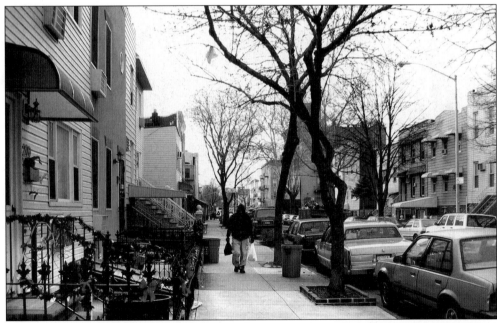

Williamsburg is not treeless and gritty, as this recent view along Devoe Street, between Humboldt Street and Graham Avenue, shows. This part of northeastern Williamsburg has clean, pleasant streets lined with well-kept private homes and small apartment houses. Devoe Street was also the setting for the images of the home and businesses of Charles Schindler on pages 78 through 81.

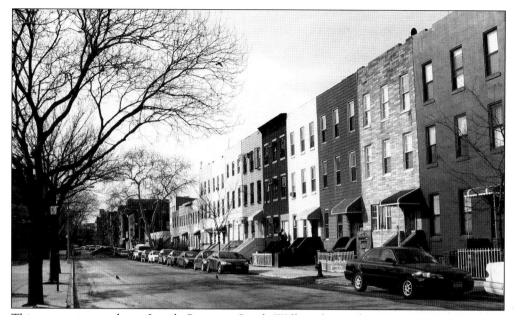

This recent image shows Lynch Street in South Williamsburg, also represented in the great *c*. 1915 photograph on pages 38 and 39. The houses on the north side of the street have been refaced but are still easily recognizable from the old image. This part of Williamsburg is a mix of Hasidic and Hispanic, chiefly Puerto Rican.

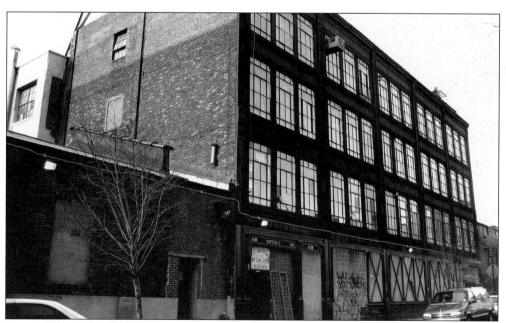

This handsome loft building at 100 North 11th Street was built in 1896 and 1897 as the Hecla Iron Works, the subject of the postcard on page 60. The façade successfully combines dark but delicately detailed cast iron with large metal-frame windows, producing an effect that is more timeless than modern. Recently granted landmark status, the building is occupied by commercial and residential tenants.

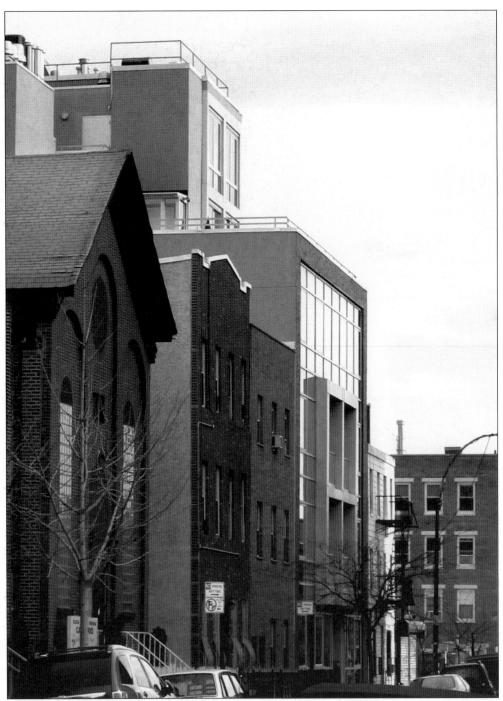

Williamsburg's past and future are condensed in this recent view east along North Fifth Street toward Roebling Street, showing at left the Iglesia Bautista Calvario and, three doors down, a sleek new condominium, which sold out before it was completed. The church, built in 1864 as St. Matthew's Evangelical Lutheran, is also shown at the bottom of page 97.